IMAGES
of America

HUDSON

This 1850s map of blocks, streets, and outlots of Hudson lists persons buying the properties. Since outlots became available for purchase in 1836, this indicates that all outlots were sold within 14 years. It is not certain why Church Street is listed as one of the streets. On other maps, it is Chestnut Street, and it remains Chestnut Street in 2010. (Courtesy of Wayne Stotler.)

ON THE COVER: The first General Federated Woman's Club (GFWC) was organized May 2, 1895, with 23 charter members. This 1890s photograph of club members was taken at the home of Etta Havens Carrithers, named Havenhurst, located on the northeast corner of Hudson Road and Route 51 (now Interstate 39). Havenhurst was built in the 1860s by Hiram Havens, son of Jesse Havens. It was razed in the early 1960s. (Courtesy of Lois Hollingsworth.)

IMAGES
of America

HUDSON

Judith A. Lampert
and Sue Keeran

ARCADIA
PUBLISHING

Published by Arcadia Publishing
Charleston, South Carolina

Printed in the United States of America

Library of Congress Control Number: 2010937136

For all general information, please contact Arcadia Publishing:
Telephone 843-853-2070
Fax 843-853-0044
E-mail sales@arcadiapublishing.com
For customer service and orders:
Toll-Free 1-888-313-2665

Visit us on the Internet at www.arcadiapublishing.com

This book is dedicated to the families and the Lake Bloomington Association, who have generously donated scrapbooks, photographs, letters, journals, and artifacts to the Hudson Area Public Library's Hudson History Room.

CONTENTS

ACKNOWLEDGMENTS

A combination of events brought this book's image of Hudson to fruition. First the foresight of the first Hudson Area Public Library District's (HAPLD) board of trustees, library director, and library consultant included a History Room in the plans of Hudson's first tax-supported library. Second the prodding of Hudson residents Emma Swope Stoutenborough and Hilda Whitwood urged someone to start a Hudson History Club (HHC). When HHC was organized, Sue Keeran and Judith Lampert became involved as coleaders. Along with HAPLD staff member Joanna Weirman and HHC member Jean Hanson, we started organizing items in the library's Hudson History Room (HHR). Third personnel from Western Illinois University visited to evaluate the library's HHR. After seeing all of the items donated to the HHR organized in obituary and subject files, bookbinders, bookshelves, and display cabinets, they asked, "Have you ever thought about writing a book about Hudson?" Joanna, a member of the HHR Committee, sent an inquiry to Arcadia Publishing. During an HHR Committee meeting, it was agreed that Sue and Judith would gather information and coauthor a book about the village. Judith wrote the text, and Sue worked with William LaBounty to develop the scanned images. The library's Hudson History Room will receive all royalties earned from the sale of this book.

There are far too may donors to the HHR's collection of information and images to name everyone individually. Thank you to each of you. Special acknowledgements go to the Sparks, Stephens, Littell, Hospelhorn, Lawrence, Systo, Whitwood, Stotler, and Ziebarth families who contributed scrapbooks, journals, obituaries, and photographs. Also, we must acknowledge the many historical contributions made by the late Beulah Wagner, Beulah Thomas, and Ruth Hamm.

Unless otherwise credited, the photographs in this book are from the HHR archives. Of course, we acknowledge the HHC for its enthusiasm, knowledge, and support. Extra-special thanks go to Kari Garman, HAPLD library director, for proofing and editing, and to William LaBounty for his professional scanning.

INTRODUCTION

The images in this book are a snapshot of Hudson's 175 years. The chapters tell how Hudson preserves history and continues to remain progressive.

The earliest settlers—the Havens, Moats, and Wheeler families—came to Hudson Township in 1829. The families settled just west of the later site of Hudson and named the settlement Havens Grove. The village of Hudson was developed as a colony in 1836, but it was not laid out around a central square as many villages were at the time. Horatio N. Petitt entered his name in the majority of Hudson Township. Petitt banded together with other colonists, and they pooled their money and formed Hudson with inlots, which were divided into blocks of lots (noted on page 2). Outlots, which were not uniform in size, surrounded the inlots. Broadway Street, running north and south, was made 120 feet wide in the center of the village. Other streets were 80 feet wide. Since historical records indicate most of the early colonists came from the Hudson River Valley or the Hudson, New York, area, that is why the name Hudson was chosen.

The foundations of Hudson were immediate. Circuit riders affiliated with the Methodist Episcopal Church began church services in homes in 1829, school was conducted in Jesse Havens' log cabin in 1830, and the land was plowed with primitive equipment in the early 1830s. By 1836, a schoolhouse was constructed; the Methodist Episcopal church was built near the Havens Cemetery (now West Cemetery) in 1849, and grain businesses were started in the mid-1850s. Going forward to 2009, Hudson Elementary was renovated and featured up-to-date geothermal heating and cooling. The Methodist (177 years), Baptist (154 years), and Christian (100 years) churches have all been kept up to date. The Hudson Grain Company now has storage for 2.84 million bushels of grain as farmers in Hudson Township continue cultivating the fertile soil and are rewarded with record bushels of corn and soybeans per acre.

Although the early settlers struggled in the beginning when Illinois plunged into a depression in 1837, their perseverance brought them the Illinois Central Railroad in 1854. The *Hudson Gleaner* reports farmers shipping cattle, businesses receiving merchandise, and passengers going on the train to Normal and other cities. From the time the railroad arrived up to the early 1900s, the Hudson business district included general merchandise stores, a lumberyard, drugstore, bank, hotel, pool hall, post office, livery stable, blacksmiths, grain elevators, and a brick factory north of the business area. Silas Hubbard, a physician, came to Hudson in 1857.

In the early 1900s, residents responded to a need for a new school. They welcomed a town hall for public meetings erected in 1917 by the Hudson Township. The early 20th century also brought destruction with a fire in January 1914 at the Cox Store and in the 8-year-old school building in the summer of 1914. A new school almost identical to the burned structure was completed within nine months.

The Hudson Lions Club and Woman's Club are two of the organizations that provide entertainment and recreational activities for the young people of the community. Summer ball programs for both boys and girls have continued since the early 1960s. A second ball field and

a new concession and restroom facility were dedicated in the summer of 2010. Boy Scout troops and 4-H clubs continue giving a foundation of leadership and citizenship to the youth.

Even as a small village in a rural area, Hudson can boast of several townspeople whose success or fame makes them stand out. Among them are Elbert Hubbard, author, lecturer, and founder of the Roycroft Shops in East Aurora, New York; John Cook, president of Illinois State Normal University in the 1890s; Charles "Buffalo" Jones, buffalo hunter, author, and cofounder of Garden City, Kansas; and Lloyd Ramseyer, president of Bluffton College in Ohio from 1938 to 1965. Charles and Ben Gildersleeve founded the Gildersleeve Seed Company in Hudson and received international awards for soybeans and corn.

Two lakes were built in Hudson Township in the 1900s: Lake Bloomington, constructed in 1929, and Evergreen Lake, constructed in 1968. They are water sources for both Bloomington and Hudson, Illinois. Lake Bloomington is residential as well as recreational. Summer cabins were erected beginning in 1930. The 1960s and 1970s saw residents starting to live year-round at the lake, and by 2010 real estate prices reached $300,000 to $1,000,000 for homes. Besides serving as a water source, the Evergreen Lake area includes Comlara Park, with a camping area and beach. The lake and park attract over 250,000 visitors a year.

Ever progressive, Hudson residents voted for consolidation of their schools with the Unit Five District in Normal, Illinois, in 1948 and for a tax-supported library in 1990. A new library building was constructed in 1995. In 2008, the Hudson Fire Protection District moved into a new $1.2-million facility.

Residents have also seen past necessities leave Hudson. From the 1850s up through the mid-1980s, there were one to three general merchandise or grocery stores in the village. The last full service grocery closed in 1985. The small grocery could not compete with the mega grocery stores within 6 miles of Hudson. The Illinois Central Railroad that revived Hudson in the 1850s removed its tracks in 1984.

Hudson's Veterans Park on Front Street centers round a memorial to veterans. The park also contains historic stones, such as the boulder marking the last stand of the Potawatomi Indians in McLean County. This event occurred just west of Hudson in 1831, and the boulder was first placed at the actual site. When Interstate 39 was constructed, the boulder was saved by moving it to the park.

As the population of Hudson has grown by over 1,000 residents in the last 50 years prior to 2010, village and township officials continue to keep Hudson a safe and attractive community in which to live. Hudson looks forward to observing its 175-year anniversary on July 9, 2011, by celebrating the past and looking to the future.

One

PRESERVING HISTORY

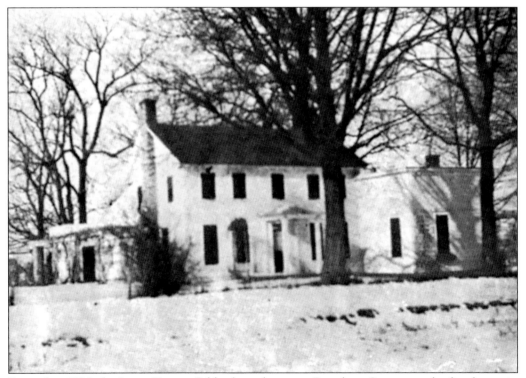

Erected in 1836, the James Turner Gildersleeve home on Broadway Street was the first house in the Hudson Colony. This residence also served as Hudson's first post office. Thomas W. Stevenson, brother of former U.S. vice president Adlai Stevenson I, and his wife, Mary Gildersleeve Stevenson, lived in the home in 1936. A 1936 *Pantagraph* article quotes Stevenson saying that Abraham Lincoln was once a guest in the house. The structure was placed on the National Register of Historic Places in 1977, but it was razed in 2000 because of its deteriorating condition.

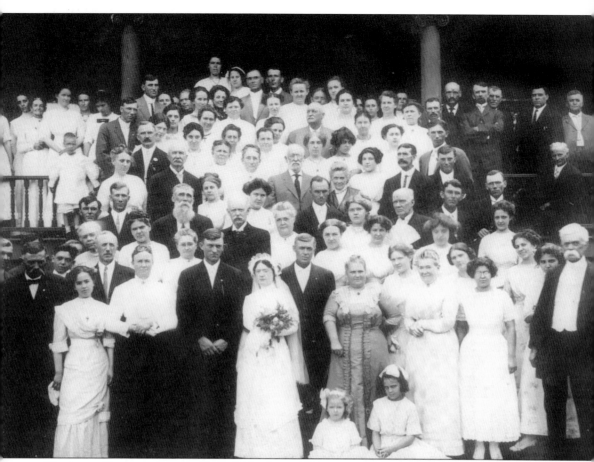

The James Turner and Nettie Ham Gildersleeve 1901 country home in Section 26 was the setting for the marriage of their daughter, Alice Marie, to Ralph Sunkel on August 21, 1912. Approximately 95 guests attended the wedding. Some of those present were the young ladies sitting—Marietta Stevenson (left), daughter of T. W. Stevenson, and Marjorie Gildersleeve Rhinehart Sleap, sister of the bride. Standing in the first row are, from left to right, possibly William Sunkel, brother of groom; George Sunkel, father of groom; Nellie Sunkel, mother of groom; Suzanne Jung Sunkel, grandmother of groom; Ralph Sunkel, groom; Alice Gildersleeve Sunkel, bride; James Turner Gildersleeve, father of bride; Nettie Ham Gildersleeve, mother of bride; Mary Alice Gildersleeve, grandmother of bride; Ruth Gildersleeve Harness, sister of bride; and Charles Turner Gildersleeve, grandfather of bride. Charles Turner Gildersleeve, son of James and Nettie, lived in the country home until his death in 2000. The house remains in the Gildersleeve family. (Courtesy of Margaret Sunkel Wright.)

On August 22, 1848, Melville Elijah Stone, the son of Rev. Elijah Stone and Sophia Creighton Stone, was born in the James Turner Gildersleeve house. In 1868, he published his first newspaper, the *Sawyer and Mechanic*, which later ceased publication. In 1892, Melville Elijah Stone founded the *Chicago Daily News*. He became the general manager of the Associated Press from 1893 to 1918. Stone died February 15, 1929, and is buried in Washington National Cathedral in Washington, D.C.

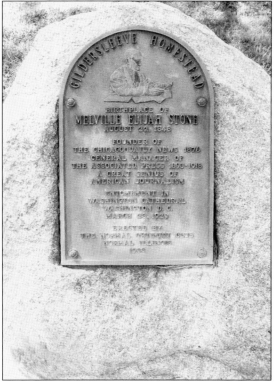

Hudson preserves its historical markers in Veterans Park. One such marker is a boulder with a plaque honoring Melville E. Stone. At the urging of Jacob L. Hasbrouck, editor of the *Daily Pantagraph*, the boulder was placed in front of Stone's birthplace by the Optimist Club of Normal, Illinois, on August 22, 1933. When the Gildersleeve house was demolished in 2000, the boulder was moved to Veterans Park on Front Street.

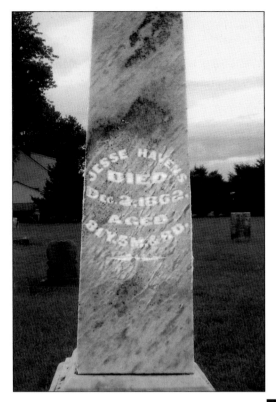

Jesse Havens (1781–1862) was born in New Jersey. He married Margaret Hinthorn in 1805 in Ohio. Both Havens and his father served in the War of 1812. In 1829, the Havens, Moats, and Wheeler families traveled in covered wagons to Illinois. They settled in a grove less than a mile west of the future site of Hudson known as Havens Grove. This was the first settlement in Hudson Township. A map published in 1856 by surveyor Peter Folsom showed Havens Grove consisting of 2,080 acres. Jesse Havens served as one of the first three McLean County commissioners in 1831. He and Margaret are buried in the West Hudson Cemetery.

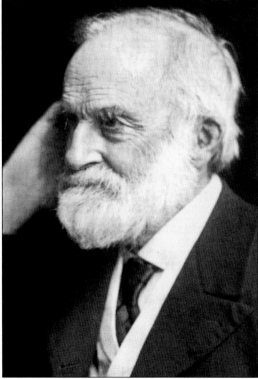

Dr. Silas Hubbard was born May 9, 1821, in Chautauqua County, New York. Hubbard received his medical degree from Castleton Medical College. The Hubbard family moved from Buffalo, New York, to Bloomington, Illinois, in the fall of 1855. Dr. Hubbard moved his family to Hudson in 1857. He was Hudson's first doctor, and his practice was widespread, as he traveled by horse and buggy to patients in White Oak, Towanda, Money Creek, and Normal Townships. After closing his office in 1900, Dr. Hubbard and his wife moved to East Aurora, New York, where he lived to the age of 96.

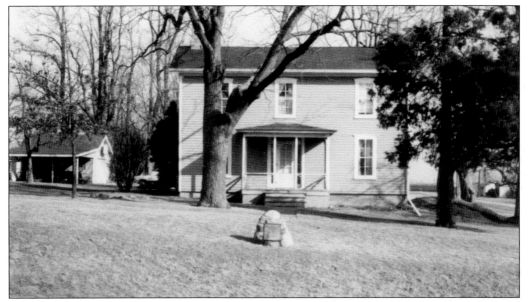

Shortly after moving to a farmhouse on the edge of Hudson, Dr. Silas Hubbard purchased lots from the Baptist church to build the Hubbard home on the corner of Broadway and Walnut Streets. The original wing was built in 1857 by Hubbard with walnut logs he helped hew. In 1872, a two-story addition was constructed in an I-shaped design. Hubbard and his wife, Juliana Frances Read, raised five children in this house. The Hubbard House was placed on the National Register of Historic Places in 1979. Current owners are the Gary Nardi family.

Dr. Hubbard studied the makeup of the brain. This diagram was found among Hubbard's medical items gifted to his great-great-grandson, Dr. Clark Heath. Segments 25 and 41 of the brain were discovered by Hubbard and published by him in 1843 and 1845 in Buffalo, New York. Hubbard was known for being eccentric and also as an herb doctor. With the help of local boys, he gathered herbal roots from the Hudson Township prairie.

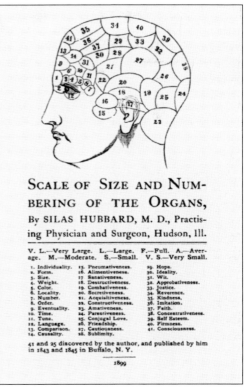

SCALE OF SIZE AND NUM-
BERING OF THE ORGANS,

By SILAS HUBBARD, M. D., Practis-
ing Physician and Surgeon, Hudson, Ill.

V. L.—Very Large. L.—Large. F.—Full. A.—Aver-
age. M.—Moderate. S.—Small. V. S.—Very Small.

1. Individuality.	15. Pneumativeness.	29. Hope.
2. Form.	16. Alimentiveness.	30. Ideality.
3. Size.	17. Sanativeness.	31. Wit.
4. Weight.	18. Destructiveness.	32. Approbativeness.
5. Color.	19. Combativeness.	33. Justice.
6. Locality.	20. Secretiveness.	34. Reverence.
7. Number.	21. Acquisitiveness.	35. Kindness.
8. Order.	22. Constructiveness.	36. Imitation.
9. Eventuality.	23. Amativeness.	37. Faith.
10. Time.	24. Parentiveness.	38. Concentrativeness.
11. Tune.	25. Conjugal Love.	39. Self Esteem.
12. Language.	26. Friendship.	40. Firmness.
13. Comparison.	27. Cautiousness.	41. Consciousness.
14. Causality.	28. Sublimity.	

41 and 25 discovered by the author, and published by him
in 1843 and 1845 in Buffalo, N. Y.

1899

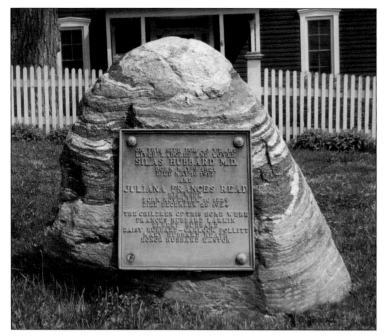

A boulder with a bronze plaque attached sits in front of the Hubbard house as tribute to Dr. Hubbard's 43 years of service to the Hudson area. The boulder was removed from Lake Bloomington when it was being built in 1929. It contains the words, "On this site for 43 years lived, labored and loved Silas Hubbard, M.D., born May 9, 1821, died May 18, 1917, and Juliana Frances Read, his wife born Nov. 16, 1829, died Dec. 18, 1924" and continues with the names of their children.

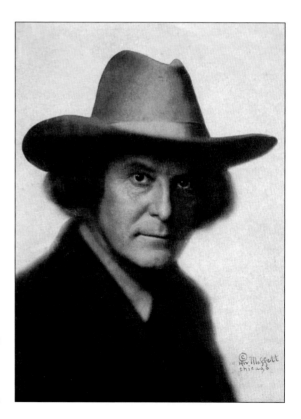

Elbert Hubbard was born in 1856 in Bloomington, Illinois. He was a year old when his family moved to Hudson. Hubbard became a lecturer, philosopher, and writer. He moved to New York and in 1876 became secretary-treasurer of Larkin Soap. Hubbard sold his interest in the company in 1892 for $75,000. He founded the Roycroft Campus in East Aurora, New York, in 1894, where craftsmen made copper items, stained glass, and furniture. Roycroft Shops and Inn still exists. On May 7, 1915, Elbert and his second wife, Alice, lost their lives aboard the *Lusitania*.

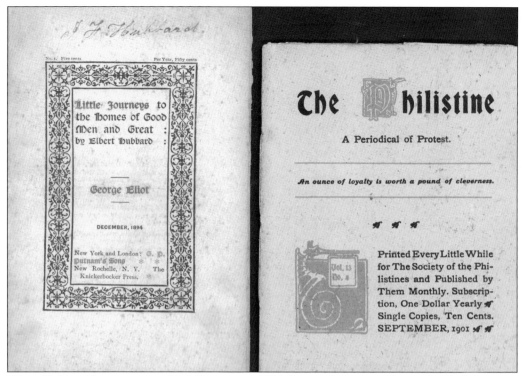

Elbert Hubbard began writing *Little Journeys* in 1894. Pictured are two of his works. *Little Journeys to the Home of Good Men and Great* was first published in 1894 by G. P. Putnam's Sons. In 1895, it was distributed by the Roycroft Press. The well-known essay *A Message to Garcia* was first put in print in the March 1899 issue of *The Philistine*. Within 10 months, it was reprinted nine million times. Hubbard began publishing the magazine *The Fra* in 1909.

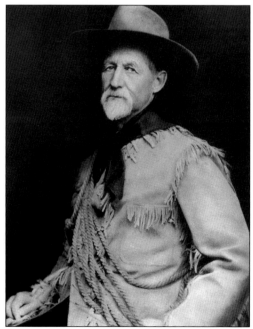

Charles Jesse Jones (1844–1919), son of Noah and Jane Jones, was born in Hudson Township. In 1864 Jones, who became known as Buffalo Jones, went west. He was a pioneer, buffalo hunter, and personal friend of Pres. Theodore Roosevelt. Jones was among the early breeders who crossed cattle and buffalo and reportedly coined the word *cattalo*. After hunting buffalo for 20 years, Jones realized buffalo were becoming extinct, and he established a ranch to save them. Jones was cofounder of Garden City, Kansas. He died in 1919 and is buried in Valley View Cemetery in Garden City.

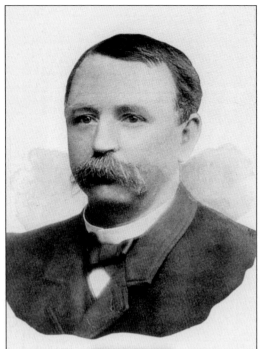

John W. Cook was born near Oneida, New York, in 1844. The Cook family moved north of Hudson in 1851. John's father, Harry Dewitt Cook, believed that the Toledo, Peoria and Western Railway (TP&W) was crossing the Illinois Central at that point, and he planned to establish a town named Oneida there. The TP&W was built elsewhere. John graduated from Illinois State Normal University (ISNU) in 1865 and was ISNU president from 1890 to 1899. Cook Hall was built in 1896 on the ISNU campus and was placed on the National Register of Historic Places in 1986. Cook was president of Northern Illinois State Normal School in DeKalb from 1899 to 1919. He died at his Chicago home July 15, 1922.

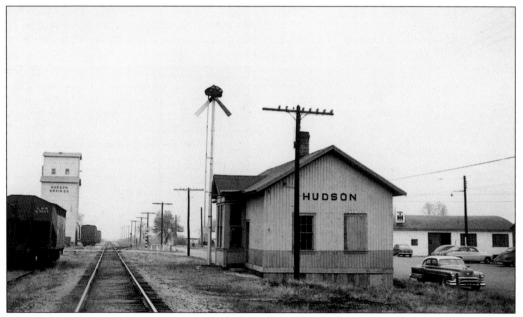

The Hudson depot stood in a prominent place on Front Street for nearly 115 years. It was erected shortly after the Illinois Central Railroad (ICR) laid the tracks through Hudson in 1854. The ICR train hauled goods and transported passengers. Passenger service ended in 1939. Jack Harvey was the last trainmaster when ICR closed the depot in 1966. The depot burned in 1975, and the tracks were removed in 1984. (Courtesy of Richard and Sue Keeran.)

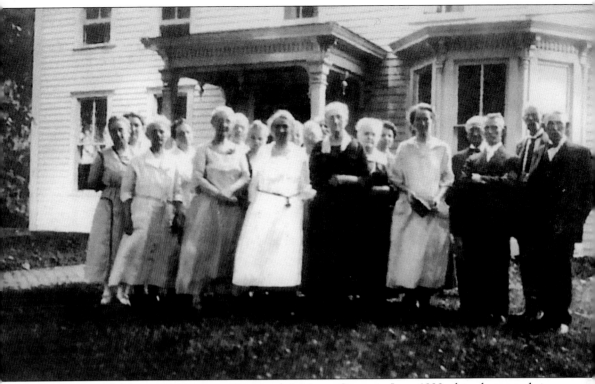

Taken at the Johnston residence at 301 North McLean Street in June 1923, this photograph is of friends and family attending a family celebration. Loretta "Lora" Johnston (1865–1943) and Nina Mae Johnston (1880–1943) were very active Hudson residents. Lora taught at the Grove School in 1900 and was officially appointed postmaster of the Hudson Post Office by Pres. Theodore Roosevelt in 1903, after having previously held the position for 11 years. She served as postmaster again from 1913 to 1937. Mae was her assistant. In 1916, Lora started the *Hudson News* newspaper. The last issue was published in 1918. Lora was state reporter for the *Pantagraph* for 30 years, secretary of the Hudson Cemetery Board, and the first director of Hudson Home Bureau. Mae was treasurer of Hudson School Townships from 1917 to 1943 and a teacher for 23 years. Pictured in the photograph are, from left to right, Sara Johnston, Irene Johnston Lawrence, Kate Skinner Bishop, Amanda Skinner, Mary Hubbard Heath, Lettie Humphries, Leah Ambrose Burtis, Lora Johnston, Mattie Morrow Johnston, Becky Bishop Ambrose, Lou Lawrence, Alice Gildersleeve Stevenson, Mrs. Ed Burtis, Mae Johnston, Rev. Fred M. Smith, William Lawrence, Tom Stevenson, and Will Humphries.

Mon. July 4th. lovely day. Hot. Our best day. Lots of people here. Enjoyed seeing old friends and watching them enjoy seeing each other. 180 here for the two days. Mrs Jordan. 96. oldest here. She stood up with my father + mother when they were married. Every thing fine except that our own folks didn't care to come. Only Lou + children + Irene Anna + Mattie here.

Tues. July 5th. Nice + hot. Got up late. Mae went to Normal. Joyce had her tonsils out. Mae picked raspberries. Cora Gastman here all afternoon. We then went to hospital to see Joyce. Jay Moore got chairs (50¢.)

Wed July 6th. Lovely day. Mae picked berries. Dr. Wilson here to get Grace's bill, Jim Ambrose promised to pay. Grace paid 46.75 rather than stand suit. Sent Jim a letter. Judson Ambrose here, Anna +

The Johnston sisters kept a diary in 1937 and 1938. It is an account of their day-to-day life in Hudson during that time. To commemorate 50 years of living in the Johnston house, Lora, Mae, and Grace Johnston held a celebration July 3 and 4, 1938. The diary records the preparation for the celebration and states that 180 people attended the two-day event. Their daily journal tells about the visitors the sisters received and everyday activities. Both Lora and Mae died in 1943, and Grace died in 1950. All are buried in the Hudson Cemetery. A copy of the diary is in the library's History Room. Melanie Morrow Stephens of Hudson is a descendent of the Johnston family.

On June 14, 1920, the Letitia Green Stevenson Chapter dedicated a boulder that is engraved "To mark the last stand of the POTAWATOMIES in McLean County, 1831." The boulder from Six Mile Creek was placed on the northwest corner of the Hudson Road. The Potawatomi village was along Six Mile Creek on land settled in 1829 by Jesse Havens. The boulder was moved to Veterans Park on Front Street in 1992.

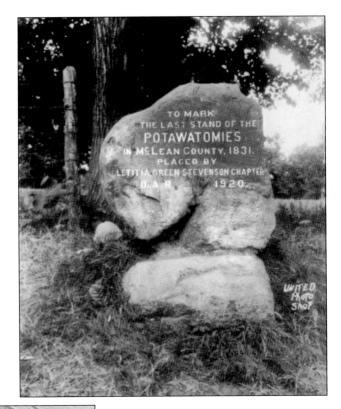

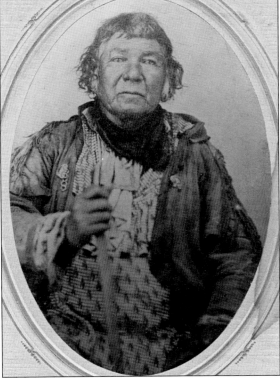

A 1982 article in *Illinois History* states Shabbona, who is pictured, was a Potawatomi loyal to the whites. An 1830s map designates a Potawatomi Village along Six Mile Creek west of Hudson. The Potawatomi left the Hudson area in 1831, as the Indian Removal Act of 1830 mandated that all Indians were to be resettled west of the Mississippi River that year. Etta Havens Carrithers, who penned *Havens Memorial*, wrote that the Potawatomi village was burned in 1831 while the tribe was on a hunting trip. The Potawatomis went from Hudson to the Ottawa and LaSalle area. They participated in the Black Hawk War in 1832. (Courtesy of Abraham Lincoln State Historical Library.)

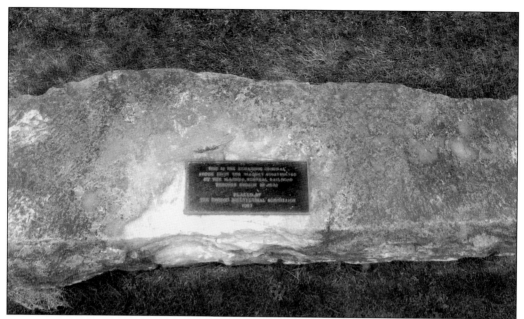

As a remembrance of the railroad that was once a vital part of Hudson, this section of limestone was saved and placed in Veterans Park in 1987 by the Hudson Bicentennial Commission. The IC through Hudson had been completed in 1854. It was a welcome sight to Hudson residents using it for transportation, mail, shipping cattle, and hauling goods. Railroad use declined, and the IC track was removed in 1984.

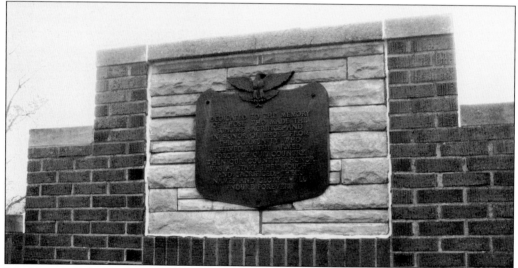

The Veterans Memorial in Veterans Park was erected by the Hudson Men's Club in July 1946. A journal lists pledges of $1,283 from 151 persons. The cost of building the memorial was $1,372. The original memorial had a glass case containing the honor roll of World War I and World War II veterans. Vandals destroyed it, and it was replaced by a bronze plaque honoring soldiers of every war. The plaque reads: "Dedicated to the memory of those who made the supreme sacrifice – and in honor of those from this community who served in the armed forces of our country. When our country's honor was at stake, they fought and sacrificed – their names and glory shall endure forever."

Two

EDUCATING THE CHILDREN

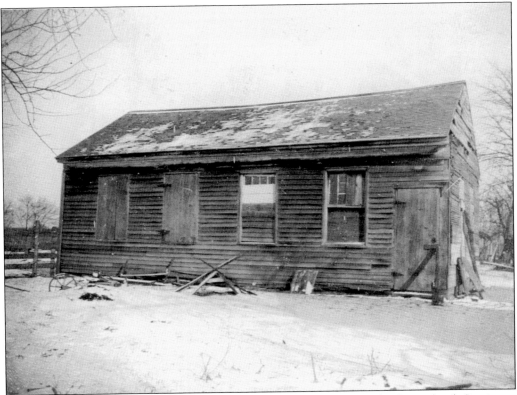

The early colonists set aside outlot 18 for a schoolhouse. In 1836, the first school, Seminary School, was constructed on this lot. Like most schools at the time, it was a subscription school with each pupil's family paying its share of the teacher's salary. Before the Baptist church had a place of worship, the schoolhouse was its meetinghouse. It was also used for political meetings. Although small, the one-room, one-story schoolhouse served as the village school until 1875. It was removed from the cemetery and is no longer in existence. (Courtesy of McLean County Historical Society.)

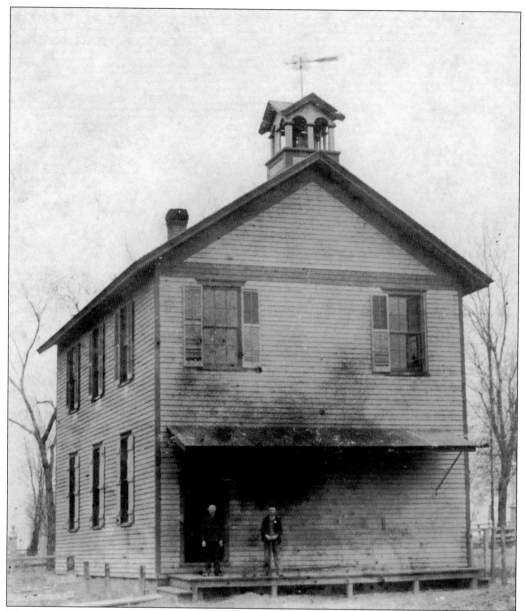

This larger two-story schoolhouse was built on the southwest corner of outlot 18 in 1875. The porch on the building was added later. There was a teacher on each level. The 1875 school building was sold to J. F. Keller in the early 1900s, moved to Block 18, and remodeled as a residence on Franklin Street

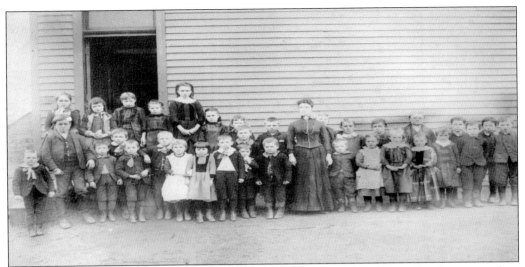

Students pose in front of the school in this late-1870s photograph. Names of students attending this school—such as Ambrose, Burtis, Cox, Gazelle, and Hinthorn—remain familiar Hudson surnames. Articles in the *Hudson Gleaner* newspaper in 1903 stated that Hudson needed a larger school, one located more suitably than next to a cemetery. During some funerals, students filed out of the school and stood by the gravesite.

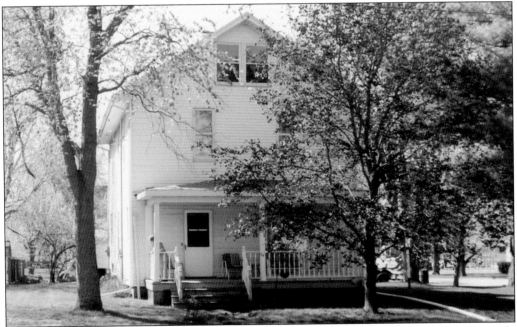

After 94 years, this house on the southeast corner of Franklin and McLean Streets, formerly Hudson's second school, remains a well maintained residence. After J. F. Keller, the Warren Miller family owned the house. The Kenneth Hilt family then purchased the house, and members of that family remain the current owners.

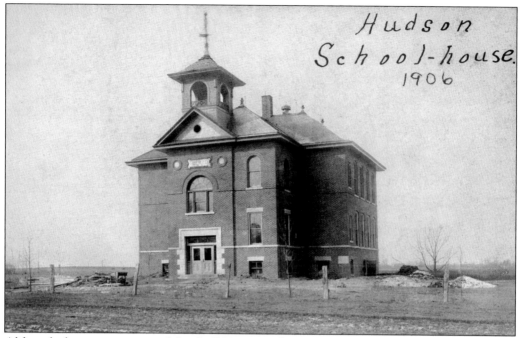

Hudson School-house. 1906

Although there was a vote on May 2, 1903, to purchase Block No. 21 for $1,200 to build a new school at the cost of $8,700 (passed 67 to 11), it was 1906 before the third Hudson schoolhouse was constructed. As pictured, the new modern school was a two-story brick building with four rooms and a basement. In order to offer two years of high school, a third teacher was added in 1907.

HUDSON PUBLIC SCHOOL
HUDSON ❧ ❧ ILLINOIS

September 7, 1903 — May 10, 1904

Presented By
Mae Johnston
Teacher

SCHOOL BOARD

K. E. Stephens	President
H. M. Cox	Clerk
I. M. Gildersleeve	Director

Pupils

Ellen Ambrose	Jennie Anderson
Ethel Arbuckle	T. Ervin Anderson
Elmen Anderson	Mae Ambrose
Perry Anderson	Ervin A. Anderson
Rena Anderson	Emily Anderson
Laurence Ambrose	Bennie Beoughter
Gilbert Boughton	Lula Brown
Edith Boughton	Royal Burtis
Eldie Bailey	Winnie Burtis
Ethel Cunningham	Nellie Calam
Hazel Condon	Samuel Coon
Carroll Cox	Samuel Daugherty
Nina Fall	Georgia Fall
Joanna Fagan	Florence Gastman
Gladys Gildersleeve	George Gildersleeve
Charles Gildersleeve	Willie Gazelle
Daisy Gildersleeve	Viola Houston
Ethel Houghton	Jay Hughes
Roscoe Hursey	Harold Houghton
Carrie Hinthorn	Minnie Hinthorn
Willie Hinthorn	Lee Harper
Marie Junk	Cedric Junk
Hurshel Johnson	Nellie Jewell
Gordon Littell	Charley Masoncupp
Claude Pettiecord	Carl Porter
Edna Skinner	Elva Silvey
Ralph Stephens	Ruth Stephens
Abe Skinner	Martha Shiner
Harold Silvey	Henrietta Thompson

❧ A. OWEN PUB. CO., DANSVILLE, N. Y.

In the late 1800s and early 1900s, students were given a souvenir booklet from the teacher at the closing of the school year. This booklet lists students attending Hudson Public School from September 7, 1903, to May 10, 1904. Mae Johnston was the teacher. Teacher salaries during this time were $50 to $55 per month.

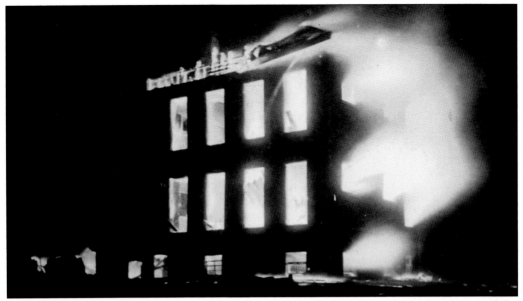

On January 21, 1914, a fire broke out in the evening at the Hudson School. The fire destroyed the 8-year-old school. An article in the *Pantagraph* reported C. I. Meyer, president of the Hudson Board of Education, stated they planned to hold school in the churches until a replacement building was erected. A new brick school similar to the 1906 structure was ready for students to attend by fall 1914. At this time there were 17 high school students, 30 intermediate students, and 44 primary students attending the school. The principal, F. S. Townley, was the high school teacher.

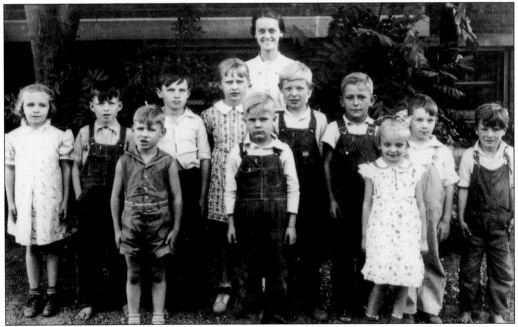

Hudson School students in grades one, two, and three pictured in September 1938 are, from left to right, (first row), John ?, Clifford Vandegraft, and Delores Ramsey; (second row) Mary Ann Boggs, Russell Bigger, Milford Arbuckle, Carman Burtis, Clifford Vandegraf, Darrell Baker, Harold Siegworth, and Eddie Arbuckle. Ina Brown was their teacher.

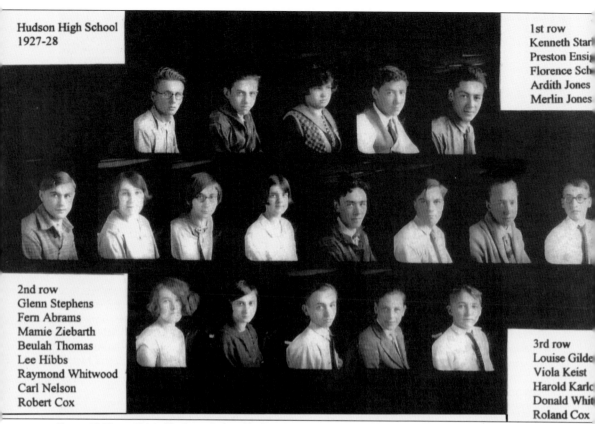

Hudson High School
1927-28

1st row
Kenneth Star
Preston Ensi
Florence Sch
Ardith Jones
Merlin Jones

2nd row
Glenn Stephens
Fern Abrams
Mamie Ziebarth
Beulah Thomas
Lee Hibbs
Raymond Whitwood
Carl Nelson
Robert Cox

3rd row
Louise Gilde
Viola Keist
Harold Karlc
Donald Whit
Roland Cox

From 1907 to 1934, Hudson School offered a two-year high school. Pictured are Hudson High School students from the 1927–1928 school year. Although there were plans for a three-year high school, the high school discontinued in 1936. By 1938, most of the Hudson High School students attended Normal Community High School (NCHS) or University High in Normal. When Hudson merged with Normal Unit District in 1948, high school students were bussed to Normal Community High School.

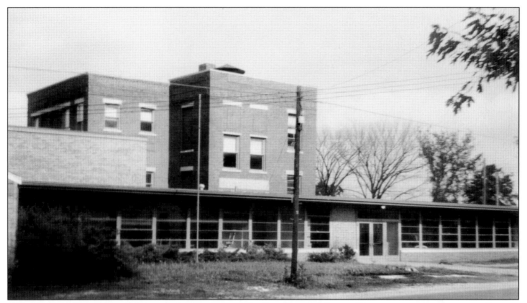

A survey in the 1940s indicated that most rural schools in McLean County were in poor condition. When a vote passed to consolidate Hudson schools with Carlock, Towanda, and Normal, all became a part of the Normal Unit District, and Hudson's rural schools closed in 1948 (except Union School). Rural students from grades one through eight were bussed to Hudson Grade School in the village of Hudson. With more space needed, an office, gymnasium, and two classrooms were added in 1953 and Union School students were transferred to Hudson Grade School.

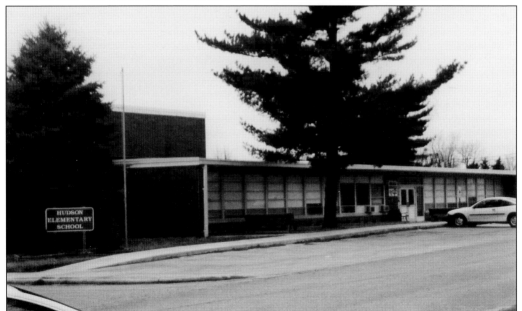

Half of the 1914 school building was demolished in June 1965. This is a 1966 photograph of the school after five classrooms were added. From 1953 to 1971, seven classrooms, a library, a kitchen, and new restrooms were added to the school. In 1970, enrollment of kindergarten through sixth grade at Hudson Elementary was 269. Seventh and eighth grades attended Normal's Chiddix Junior High in 1965. Hudson students were transferred to the new Parkside Junior High in 1975.

27

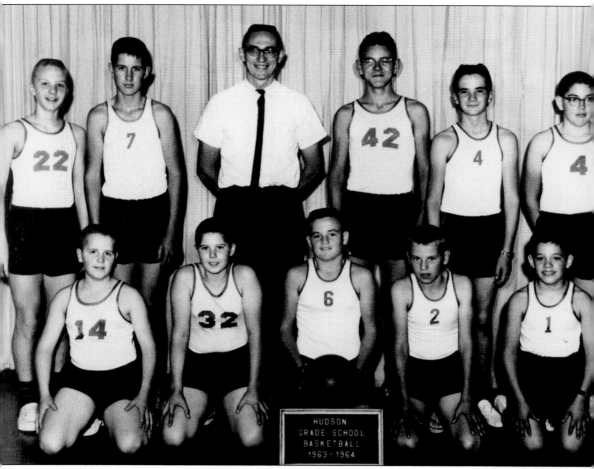

Hudson Grade School had basketball teams for several years. Their schedule included grade-school teams in the Unit 5 School District. The 1963–1964 basketball team includes, from left to right, (first row) Steven Downen, William Schroeder, Sam Anderson, Donald West, and Thomas Engle; (second row) Anthony Collins, Steven Silvey, coach Wayne Patkunas, Russell Garrett, Glen Bates, and Steven Hospelhorn. To cut costs, the Unit 5 School District's grade-school basketball program discontinued in the 1980s.

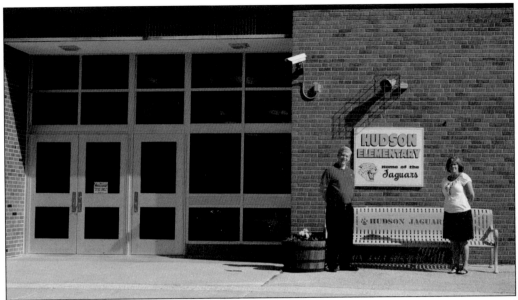

All-day kindergarten classes began in 2003, and sixth graders transferred to the old renovated NCHS, renamed Kingsley Junior High. In 2008, geothermal heating and cooling were installed at the school. In the summer of 2009, Hudson Elementary was renovated. The nearly $2-million project included safety and security improvements, new walls and windows, and a room addition for a media center. After 103 years, the school entrance was changed from the east to the south. Pictured outside the new entrance are principal Scott Meyer and school secretary Denise Myers.

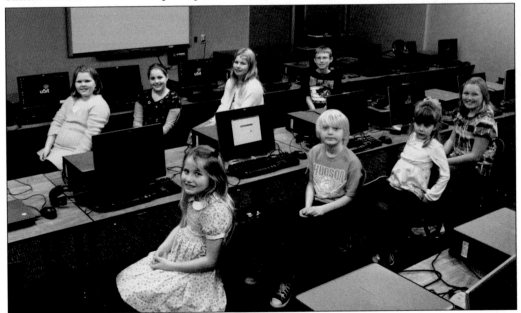

In 2010, Hudson Elementary School remains a part of Normal Unit 5 School District. Enrollment for 2010 was 290. The school has two classrooms per grade for kindergarten through fifth grades. Students sitting in the new media room are, from left to right, (first row) Sadie Emmert, Logan Saufley, Ellie Hill, and Savana Mattson; (second row) MacKenzie Funk, Gracie Edwards, Noel Emmert, and Dalton Corcoran.

DESCRIPTION OF THE BOUNDARIES

Of the School Districts as now Organized in this Township.

This Platt was coppied from the Platt Book in the County Clerks office being a copy of the latest Platt filed in that office

John M. Blough Treas.

The following is a Correct Plat of the School Districts in this Township, drawn and numbered in accordance with the foregoing of the Boundaries of said Districts.

NOTE.—The square bounded by the heavy lines represents the original Township, the squares on the outside represents sections in adjoining Townships.

The locations of the eight school districts in rural Hudson in 1878 are shown on this map. Grove School District No. 198 closed in 1911. Herring District No. 195 in Section 34 was formed in 1875 because of the distance from Skinner School, and roads were difficult to travel. In 1903, Stella Steel taught at Herring School, which shut its doors in 1937. Photographs were not found of Herring School. With a vote to consolidate with Normal School District, Skinner, Holder, Oneida, and Pleasant Grove school districts closed in 1948. Union School closed in 1953.

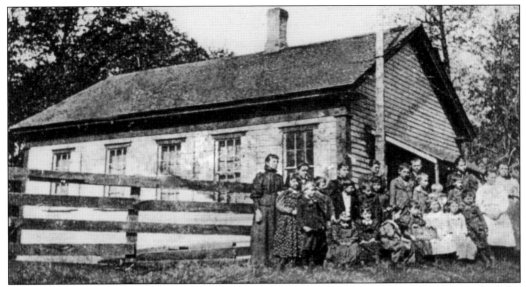

In the early 1830s, Jesse Havens erected a double log cabin in Section 17. The west end of the cabin served as the first school in Hudson Township. The first Grove School was built on the east side of the road west of the West Cemetery in the early 1840s. The new Grove School, built in 1856, pictured above, was built just west of the southwest corner of Route 51 (now Interstate 39) and Hudson Road. Children west of Hudson attended Grove School. Other school districts were being organized, and by 1911 there were so few students attending Grove School No. 198, it merged with Hudson No. 197 in the village of Hudson.

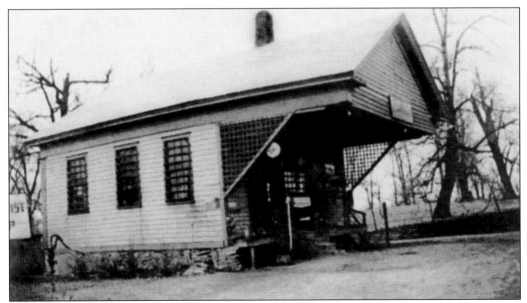

Pictured is the Grove School building as it looked when Frank Prahm purchased it in 1931. He moved it south of its original site for use as a lunchroom. The school building and a gas station were demolished, and a new Standard service station was erected in the late 1950s. Robert Brokaw and Jeffrey Emmert operated the gas station in 1983 as a Shell station. The structure was demolished to make way for the new Interstate 39 that opened in 1993.

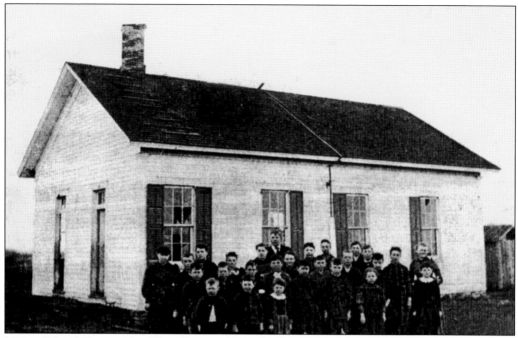

Union School District No. 201 in Section 11 was built in the 1840s by stockholders of the Hudson Colony. Samuel Cox donated the land. Charles "Buffalo" Jones attended this school. In 1862, with more room needed, the abandoned Oneida Station store was moved to Section 15, renovated, and used as the school. Union School District was split in 1867, and the Oneida School District No. 200 was established near the highway north of Hudson. Union School District's new schoolhouse in 1870 is pictured here. It was destroyed by fire in February 1920.

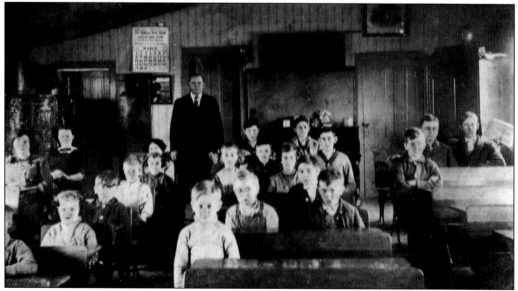

After Union School burned, a new $8,500 school was completed by the fall of 1920. The photograph is the interior of Union School in 1914. Although citizens voted to consolidate with Normal School District in 1948, and all other Hudson rural schools closed, Union School remained open until construction of two classrooms at the Hudson School in 1953.

The old Union School was used by the American Legion Post 124 and the Boy Scouts. It then stood vacant. Ronald Shelton bought the schoolhouse in 1990 and renovated it into a residence. As he completely gutted the building, Shelton was determined to keep the gems of the 70-year-old building—original wood floors, wood and glass library serving as a breakfront, textured glass on the door to the children's washroom, and the front entranceway made of bird's-eye pine.

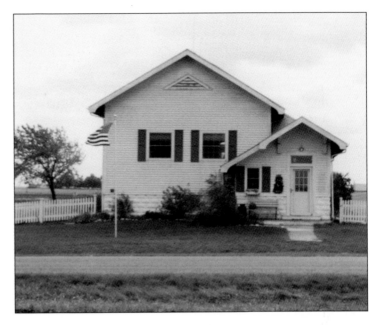

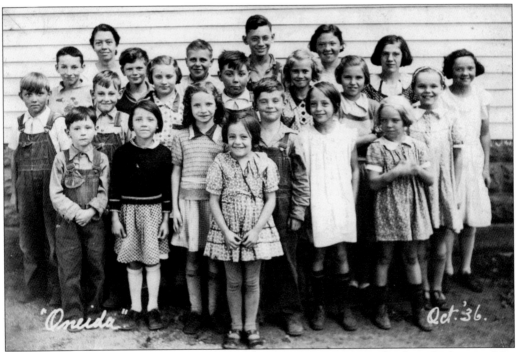

The first Oneida School was a log schoolhouse in the 1850s. In 1867, a school was built west of the railroad in Section 9, which was more centrally located. Students pictured in October 1936 with their teacher, Blanche Nelson, from left to right are (first row) Yvonne Turner; (second row) Edwin Hospelhorn, Rosalie Thacker, Doris Campbell, Raymond Hospelhorn, Monica Keene, and ? Keene; (third row) Harley McClure, Vernon Hinshaw, Ruth Campbell, Delmar McClure, Juanita Stephens, Marjorie Starkey, and Mildred Wagner; (fourth row) Robert Campbell, Clarence Hospelhorn, William Starkey, Bert Craig, Zelma Thacker, Florence Hospelhorn, and Geraldine Thacker.

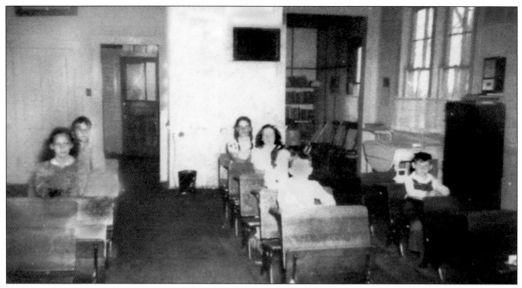

To comply with state requirements, the Oneida schoolhouse was remodeled in 1916. The Church of the Brethren and the Christian Church congregations met at Oneida until they had buildings constructed. The students pictured at their desks in 1948 from left to right are (first row) Dorothy Neal and John Howard; (second row) James Weirman, Judith Young, unidentified, and Evelyn Howard; (third row) Richard Downen. This was the last class to attend Oneida School. Harriet Young was their teacher. (Courtesy of James Weirman.)

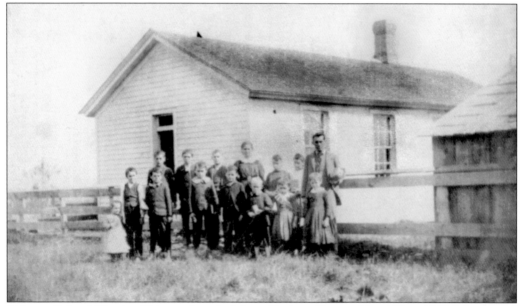

Skinner School District 196 was detached from Hudson District No. 197 in 1863. The school building was built in Section 26 on 0.25 acres bought from Mark Skinner for $10. Because of a delay in purchasing a site for the school, the schoolhouse was not built until 1865. Students posed in front of the Skinner schoolhouse for a photograph around 1885. S. Y. Gillan taught at Skinner School in 1871. He would later become a well-known lecturer and publisher. The school merged with Normal Unit District in 1948.

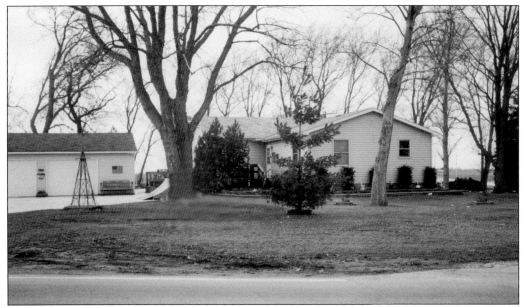

The Skinner Schoolhouse was moved further north and west of the original site when the pipeline was laid from Lake Bloomington to Bloomington in 1930. With an addition and remodeling, the structure became a residence. It is pictured above as it appears in 2010. The Carl Maucks lived in the house from the 1960s to 1970s. The Thomas Barnes family are the current residents.

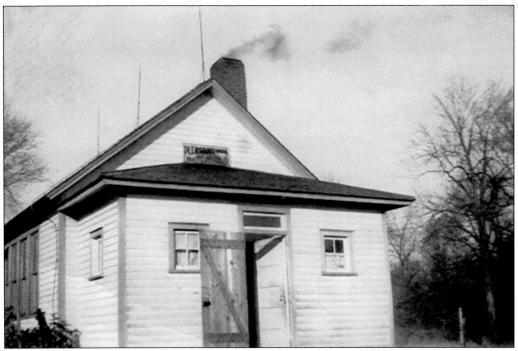

Because of trouble between the timber and prairie groups at Union School District 201, the Pleasant Grove School District No. 202 was formed in 1867. The schoolhouse was built at the center of Section 12. A second schoolhouse was built in front of the first school building, and it was ready for school in September 1892. The first schoolhouse was sold in 1894 and removed.

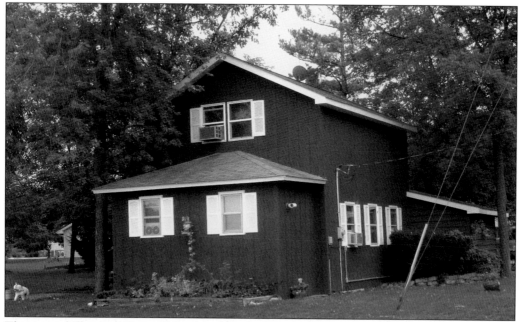

The second Pleasant Grove School building was remodeled for a residence. The Isley family added the second story. Section 12 is part of the Lake Bloomington area. Although it has been passed down that the area was referred to as "Hell's Bend," few people remember the animosity that existed between the timber and prairie groups. The school merged with the Normal Unit District in 1948. Judith Keen has owned the residence since May 2002.

Kaufman School District No. 194 detached from a school in White Oak Township in 1875. Since the district was deemed too small to operate, it added two sections. In 1878 a schoolhouse was erected in the northeast corner of Section 31. The building site was bought from Christian Kaufman. M. L. Ramseyer was a director of this school for several years. His son, Lloyd Ramseyer, attended Kaufman School. Lloyd served as president of Bluffton College in Ohio from 1938 to 1965.

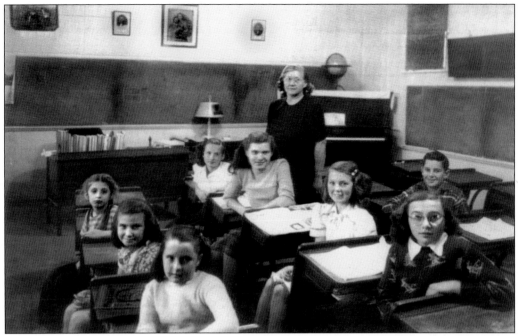

This photograph shows the interior of Kaufman School in 1948. The eighth grade students are, from left to right, (first row) Dorothy Ann Schertz, Joan Logston, and Kay Stephens; (second row) Gracelyn Miller, Wanda Stephens, Shirley Logston, and Joy Miller; (third row) Larry Jones. The Kaufman School consolidated with Normal Unit District and closed the spring of 1948.

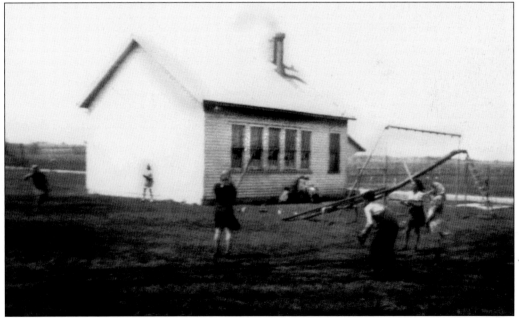

Residents living on the west side of Grove School complained about the distance to school and impassable roads, so a schoolhouse was built at the northwest corners of Section 29 in 1878. This school was named Holder School, as the site was on land owned by C. W. Holder. Mae Johnston taught at Holder School in 1878.

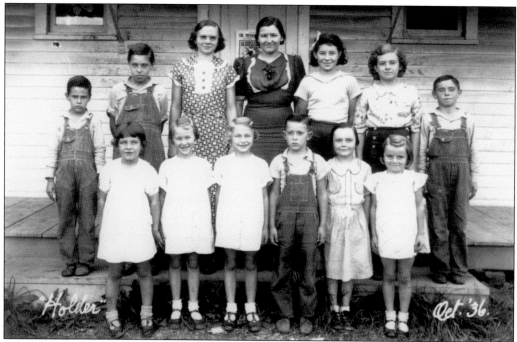

Although Holder School had one of the smallest enrollments, the building was always repaired and improved to meet state requirements. Standing in front of Holder School in 1936 are, from left to right, (first row) Ann Birky, Lois Klump, unidentified, Delmar Jones, Lena Mae Durst, and Betty Burrows; (second row) William Birky, Richard Birky, Frances Hospelhorn, Augusta Stevens (teacher), Margaret Birky, Betty Schwartz, and James Birky.

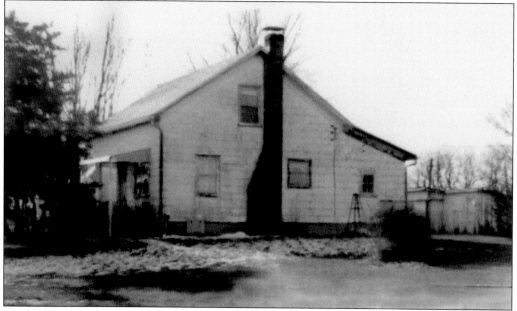

Holder School was removed from its original site to the west side of Ropp Road, formerly East White Oak Road, and remodeled into a residence. This photograph depicts the residence as it appears in 2010. This was the home of Edward and Lola Madix for several years.

Three

KEEPING THE FAITH

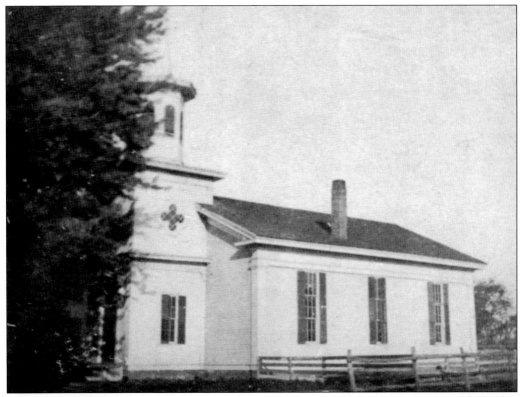

As stated in the Official Journal of the Central Illinois Conference, the Hudson Methodist Episcopal (ME) church congregation was organized in Hudson in 1831. It is the oldest Methodist church congregation in the Vermillion River District. Jesse Walker and H. Tarkington, both with the Methodist conference, preached at Havens Grove in 1829 in Jesse Havens' home. The first Methodist church building was erected 1845 in the graveyard known today as the West Cemetery. Pictured here is the church built in 1858 at its present site on the corner of Franklin and McLean Streets.

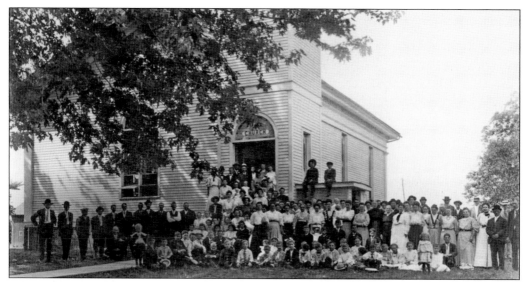

During 1907, the ME church was raised and a basement and stained glass windows were added. The sanctuary was changed to face the west, as the remodeling project included a change in the south entrance and bell tower and dividing a portion of the original sanctuary with vertically sliding doors to provide Sunday school classroom space after worship. This photograph was taken after the dedication service of the newly renovated sanctuary and basement addition.

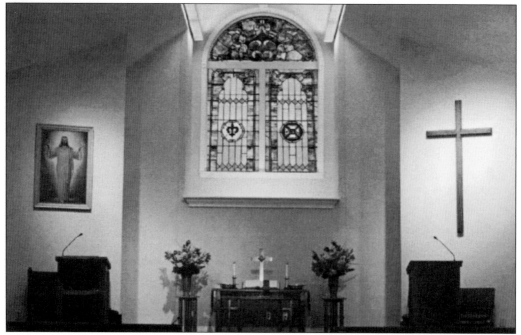

The ME church's name was changed to United Methodist after merging with the United Brethren in 1969. A major renovation and expansion of the church, built in 1858, was completed in 2001. The $800,000 project included a remodeled sanctuary with seating increased from 140 to 240. Renovation included office space, kitchen and fellowship hall expansion, addition of two accessible basement restrooms, narthex addition, and the exterior. The dedication service was April 22, 2001. This interior view of the sanctuary was taken for the 175-year celebration in 2008.

The women of the church have always been an integral part of the church body. Although the name of the Methodist ladies group has changed from Ladies Aid to Women's Society of Christian Service and now the United Methodist Women, they continue with mission work and contributing financially to the church. In 1928, they served threshing dinners at 50¢ a plate, serving 546 men and netting $184.52. A few members are pictured at a special event in 1965.

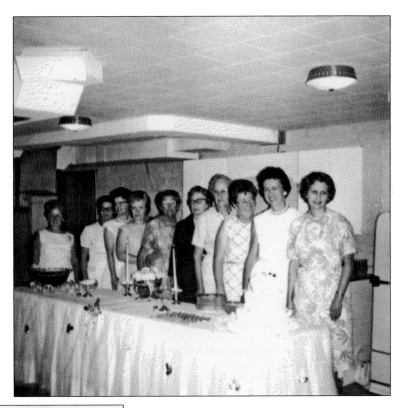

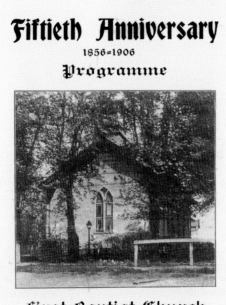

Fiftieth Anniversary

1856=1906

Programme

First Baptist Church

HUDSON, ILLINOIS,

Sunday and Monday, May 27=28, 1906.

The Hudson Baptist Church was organized May 28, 1856. They started meeting in Hudson's first schoolhouse. A building committee was chosen in 1858. Deacon J. H. Cox donated a site at the corner of Walnut and Broadway Streets. Money was borrowed at 12 percent. The first public oyster supper in Hudson was served by the women to benefit the new church on July 4, 1860. The dedication of the pictured structure occurred August 1860.

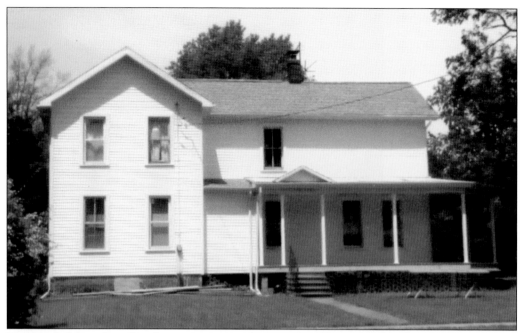

In charge of plans for a church parsonage were deacons Cox, Hamm, and Ambrose. The parsonage was constructed in 1884 at a cost of $1,269. The last minister to reside in the residence was Rev. Roger Strunk in the 1980s. The 1884 house still stands on the northeast corner of McLean and Walnut Streets. It is pictured after an upgrade in 2009.

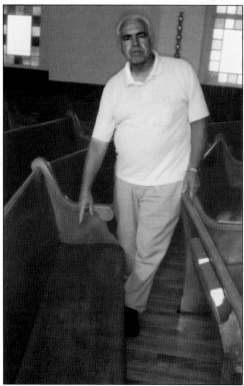

A newly installed 12-lamp chandelier positioned in the center of the church fell on a pew in the Baptist church during an 1890s service. Wayne Stotler points to the area of the pew where the fixture fell. Stotler is the great grandson of Joseph Darling Gildersleeve, one of the original Hudson colonists who bought four shares in the Hudson Colony.

In 1890, the Baptist church was remodeled and new pews, baptistery, pulpit, stained glass windows, and a parlor with dressing rooms were added. Lightning struck the church roof in 2009, and a new steeple was added when the roof was repaired. Pictured is the Baptist church as it appeared in 2000. In addition to the new steeple in 2009, new doors and a new sign have been updated since 2000.

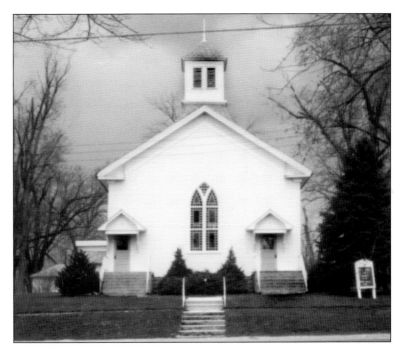

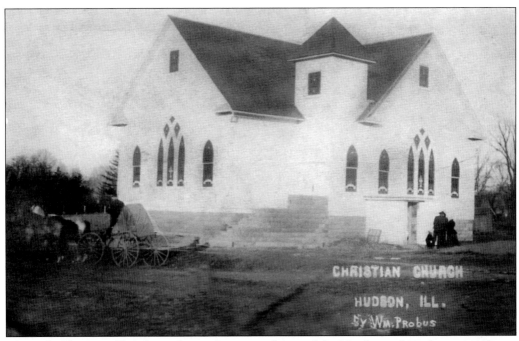

The early Christian Church worshipers first met in homes. Jehu Hinshaw solicited an evangelist to conduct a revival the winter of 1877 at the Oneida School. The church was then organized with services at the schoolhouse. After a revival in January 1893, a hole was chopped in the ice at the Mackinaw River, and 17 people were baptized. The schoolhouse became too small for worship, and land was bought at the corner of McLean and Clinton Streets in the village of Hudson for $400. Pictured is the Hudson Christian Church that was dedicated February 6, 1910.

Report of Receipts and Expenditures of the Oneida Christian Church, Hudson, Illinois.

Cost.

Chicago House Wrecking Co	$1,626 88
Metcalf & Co., plaster &c...	74 15
Gaston Contract	530 00
Seats	325 00
Freight	16 08
Plastering	124 64
Lots	400 00
Painting	116 00
Tank	14 50
A. Skinner Cement &c	59 38
Furnace	155 00
Lentz & Gaddis	40 40
Cement Blocks	4 80
Foundation	350 00
Lights	50 90
The Misses Wheeler	16 50
Harvey Messer	10 00
Organ, Insurance, &c	142 49
Tile	1 50
Cellar Windows	53 64
Chairs	65 00
O. McNemar to car fare	16 00
To laborers	468 70
W. B. Kimler	11 50
Printing	.6 25
Total,	**$4,678 41**

Amounts Contributed

Ladies' Aid Society	$410 00
Thomas Junk	225 00
Wm. Junk	225 00
Mrs. Dora Craig	187 50
Corn Donated, collected by Lulu Hinshaw and Lida Brown	172 25
Levi Hinshaw	130 00
Mrs. Mary Brown	125 00
Mrs. Jane Junk	120 00
John McClure	120 00
Mrs. Mary Stephens	100 00
Mrs. Jane C. Junk	85 00
Miss Louisa Junk	72 50
Frank Hinshaw	77 00
George Ames	57 50
Mrs Lillian Junk	60 00
J T. Shephard	50 00
W. H. Shiner	51 50
Thomas Stephens	45 00
Emery Bigger	45 00
Mrs. David Smith	42 50
Mrs. Lillian Junk, chain letter	41 68
Mrs. Ames to organ fund	40 49
Mrs. Mayme Lewis	35 00
Mrs. Ames, chain letter	31 14
Mrs. Lizzie Russell	30 00
Mrs. Etta Platt	25 00
A. W. Starkey	25 00
Dr. S. S. Boulton	25 00
R. A. Essign	25 00
Osceola McNemar	25 00
Geo. Ames	20 00
George Priest	20 00
Clint Myers	20 00
W. H. Messer	20 00
Frank Maple	20 00
Jehu Hinshaw Family	17 50
Thomas Craig	17 50
James Stephens & Bros	17 50
Mrs. Reynolds	17 50
The Misses Wheeler	16 50
George Craig	15 50
Robert Russell	15 00
Robert Brown	15 00
Bert Kimler	15 00
Ellen Swope	15 00
Sarah Craig	15 00
Caufield	12 50
Inis Rusick	10 00
Sarah Davis	10 00
Mollie Myers	10 00
W. H. Walston	10 00
Wm. Morrow	10 00
Sam Thompson	10 00
P. Y. Benson	10 00
Mrs. Snavely	10 00
George Davis	8 25
Emery Stephens	5 00
Joe Le Voy	5 00
Mrs. Mary Johnston	5 00
Mrs. Margeret Manker	5 00
Willie Myers	5 00
James Priest	5 00
Eddie Kearfott	5 00
Mrs. Lida Hinshaw	5 00
Johnson sisters	5 00
Dr. J. O. Johnson	5 00
A. W. Skinner	5 00
O. H. Archibald	5 00
J. R. Porter	5 00
Thomas Raycraft	5 00
W. P. May	5 00
Mrs. Harriet Thompson	5 00
E. S. Walston	5 00
Mrs. Susie White	5 00
Wm. Wordon	5 00
Mattie McClure	5 00
Thom. McClure	5 00
Holly Stephens	3 00
J. F. Keller	3 00
Louis Wheaton	2 00
Floyd May	2 00
Ira Hinshaw	2 00
Bert Kern	2 00
Mary Hinshaw	2 00
Sam Swope	1 50
Barney Rathbun	1 50
Morris Junk	1 50
Arthur Junk	1 50
James Rankins	1 00
Viola Spencer	1 00
Blanch Hinshaw	1 00
Walter Burkey	1 00
Meyer Livingston	50
Total.	**$3221 31**

Listed at left are donations that made the building of the Hudson Christian Church possible. The total of $4,678.41 included materials, labor, and furnishings. Levi Hinshaw, Emery Bigger, Thomas June, William Junk, and Rev. Osceola McNemar served on the building committee. In 1963, the church was enlarged with a 40-foot-by-40-foot addition for classrooms and a basement at a cost of $12,395. Later a kitchen was added, and in 1966, the sanctuary was renovated with new hardwood flooring, carpeting, and lighting.

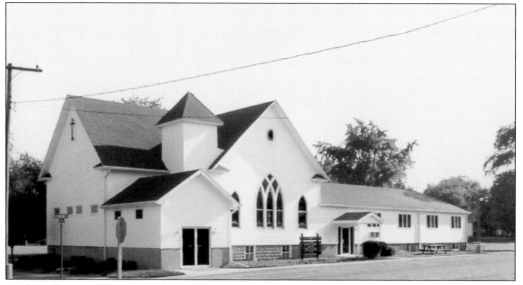

With such a small group in the early 1920s, the Christian Church congregation was forced to abandon services. The Ladies Aid Society continued, and through their efforts, the building was kept in repair and bills paid. The church became active again with the arrival of William Simer. Several ministers served the church until September 1957 when Rev. Merlin C. Stratton was appointed the minister. During his ministry, attendance records were broken. The Hudson Christian Church celebrated 100 years July 31, 2010.

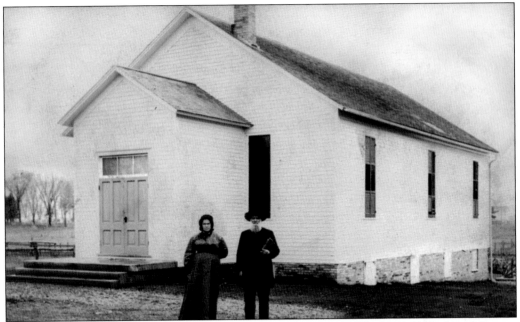

The Church of the Brethren was organized with 21 members in 1865 by James R. Gish and George Gish. Since ministers baptized by dunking parishioners in the Mackinaw River, the church was frequently referred to as the Dunkard Church. In 1875, a meetinghouse was built 2 miles north of Hudson. The 32-foot-by-48-foot church cost $2,000, and T. D. Lyon was the first minister. Without transportation to the country, members living in Hudson wanted to move the church to Hudson. It was relocated to the village in 1908 and remodeled. Serving the church for 12 years, Rev. J. H. Neher was its last pastor.

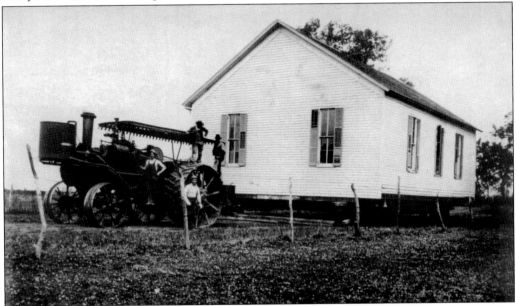

John Lohr bought the old Dunkard Church for $200 and moved it 3.5 miles northeast of Hudson. This 1927 photograph shows the church as it was being transported. Lohr added the second floor and made it into a duplex with a grandparent living on one side and his family on the other.

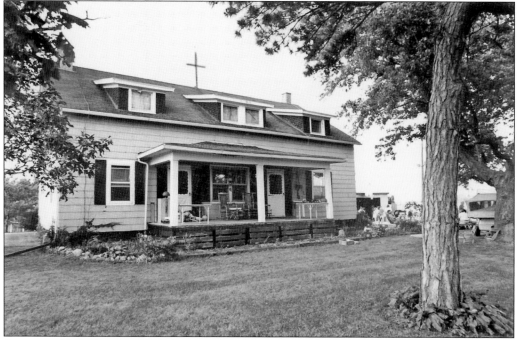

Steven and Jane Convis Chestney moved to the Lohr homestead from Bloomington on January 18, 1974. When they moved into the house, there was no plumbing. Steven, a plumber by trade, put in pipes and completed other renovations. Pictured above is the 12-room residence as it appears in 2010. The Chestneys raised their four children in this house. They continue to live in the residence.

Steven's dream was to have a family band. He played guitar; Jane played keyboard and sang; Julie played drums; Christopher played guitar; Stephanie sang; and Joshua played bass guitar. Their first performance as the Chestney Family Band was in 1982 in a church at Lake Bloomington. The band played for the Hudson Prairie Days Festival each year, and they have played at charity benefits and other venues since 1982. Pictured, from left to right, are Christopher, Joshua, Stephanie, Steven, and Jane Chestney. Not pictured is Julie, who lives out-of-state.

Four

FARMING THE LAND AND RAISING ANIMALS

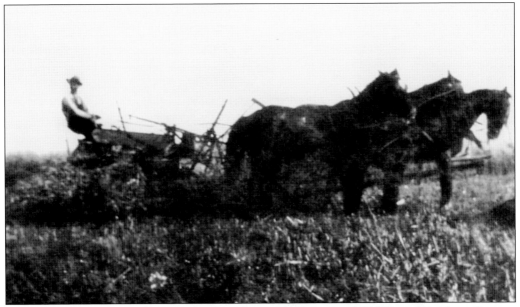

Farming began in the Hudson area in the spring of 1830. In *Good Old Times in McLean County, Illinois* 1874 by Duis, it is stated that Benjamin Wheeler, Jesse Havens' son-in-law, used a primitive land side, shear, and wooden moldboard that he made when he started farming. This farm was part of the Havens Grove settlement west of Hudson. As shown in this photograph, where the Ziebarth family farmed near the Mackinaw River, cultivation became a little easier in the early 1900s with horses pulling implements. (Courtesy of Gary Ziebarth.)

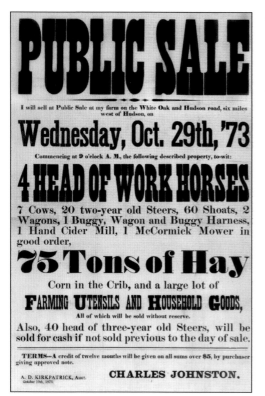

PUBLIC SALE

I will sell at Public Sale at my farm on the White Oak and Hudson road, six miles west of Hudson, on

Wednesday, Oct. 29th, '73

Commencing at 9 o'clock A. M., the following described property, to-wit:

4 HEAD OF WORK HORSES

7 Cows, 20 two-year old Steers, 60 Shoats, 2 Wagons, 1 Buggy, Wagon and Buggy Harness, 1 Hand Cider Mill, 1 McCormick Mower in good order,

75 Tons of Hay

Corn in the Crib, and a large lot of

FARMING UTENSILS AND HOUSEHOLD GOODS,

All of which will be sold without reserve.

Also, 40 head of three-year old Steers, will be sold for cash if not sold previous to the day of sale.

TERMS—A credit of twelve months will be given on all sums over $5, by purchaser giving approved note.

A. D. KIRKPATRICK, Auct. **CHARLES JOHNSTON.**
October 10th, 1873.

This Charles Johnston 1873 farm sale bill was found folded in a scrapbook donated by the William Lawrence family. Since it was found in pristine condition, the sale bill was professionally framed and hangs in the library's History Room.

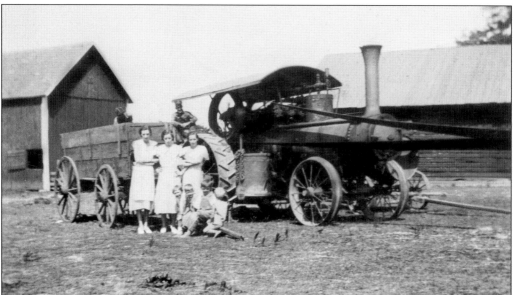

Steam engines were used by farmers in the early 1900s up to the 1940s. The engine pictured above is belted to a threshing machine. Area farmers knew this steam engine belonged to Vernon Littell, as water tanks were mounted on it. Threshing was done by Littell for the "threshing run" southeast of Hudson. Edward Stuckey, who lived southwest of Hudson, was a thresher for 46 years. A quote from him in the *Pantagraph* said that he wore out four steam engines. At one time, Stuckey had 40 men in his threshing crew.

Left column:

1915

g. 5. hrs younger half sister to Mr. C.B
Augetins to be bord – at Allentown.
She returned by Intra Urban to Blooming
ton where we stayed all night.

Aug. 10. Large red heifer was bord at Mr. H's –

14. Saturday night. Took shoat eared cow to
Mr. Humphris – Brought her and two
heifers home Sunday morning –

19. Returned mulry heifer – Was bord.

" Threshing at Hanlys was finished
the middle of the forenoon. A raw wind
has been blowing from the E.N.E. and
for a short time this morning it swung
into the S.E. It was drizzling when
Hanly finished & gradually came on harder. It rained all P.M. & night & was the biggest
rain we have had since the 10th of May 1914.
Threshing began again Monday morning
the 23d.

25. Our threshing began about 3.30 P.M.
First threshed the south 20 of the East 40. This
made 83 bus per acre. We next threshed 20 acres
on the south side of the seventy. This made
The third piece was the North side the 40 across
the road 22 acres threshed out exactly 2000 bus.
91 per a.
Total Tally was 5504 or 89% per acre.

Aug. 31. This P.M. car of Rock Phosphate arrived for self
& D.L. & T. Gildersleeve. Yrs. Craig & Ed. Hamm
from which I will spread 10 tons on west half
of south 40.



1915

Oct. 7. Delivered 32 head hogs to Maple dl. at 7
and one sow to Silvey. Total amount $537.88

Oct. 13. Max Newbum began to work by the day at 1
worked every day in Oct. and 5 days in N
Max began husking corn Nov. 6 –
Clarence husked first load of corn Nov 3. One
load next day first full day on Fri. Nov.
Husked in the eleven acre field east of bar
The total bushels measured as husked, wor

Nov. 4. Took the old spot to Tom. Moore's bull.

" 9. The first field husked, the eleven acres was fin
ished this evening. The east twenty
in the south forty taken next.

" 19. Settled up with Clarence for mo. of Oct. and
all time complete up to beginning corn husking.
After deducting what he owes for grain etc. I owe
34.00. Did not write check as was afraid there w
not money in bank.

Dec. 11. About this date bord spot & old red at Moor
16. Went to Chicago. Visited the O Cell factory – Called on Guy
Bruster.

" 25. Just before Christmas, we had two young calves. A
from the mulry cow. This calf has large white spot
forehead, lower half of tail white. white under line &
spots.

" 30. A steer from the Hutchison heifer. This calf has
horse star in white on forehead with open side up.

Jan. 16. Sunday. Very cold day. The small tilted cow had
in field, but we got it home all right. except was on
from little. Steer calf.

Beginning September 9, 1914, John D. Lawrence started writing "anything of importance that occurs on the farm or in connection with the business," including weather conditions, in his farm journal. Details were given on buying and selling of livestock, birthing of calves, and planting and harvesting of crops. For example, his first entry stated, "This morning we had a new calf by Spot. A very fine male." His first year's writings state that they finished husking corn on December 7, and he told of buying cattle at an auction where he learned that a friend had smallpox. Sprinkled in with farming activities are domestic happenings such as, "We papered the dining room."

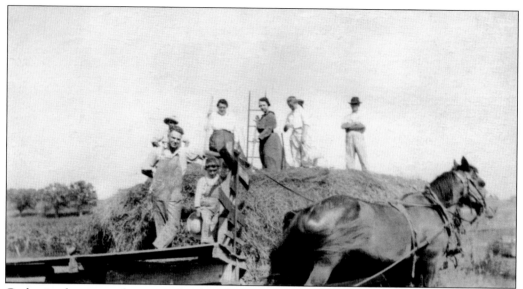

Gathering hay was a big event for the whole family. This 1918 photograph was taken during threshing at the Herman Schneider farm east of Hudson. T. P. Rogers owned the property in 1866. Schneider bought the farm in 1901, and a member of the Schneider family lived on this acreage until 1975. George and Mary Verne bought the house plus a few acres in 1989 from Hugh and Beverly Parker.

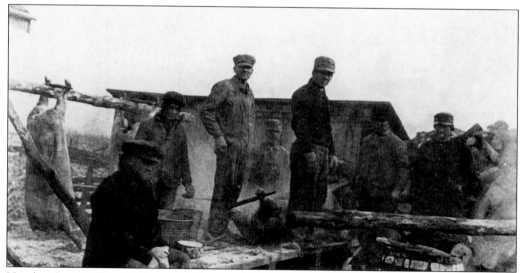

Hog butchering day usually included more than one family. This early 1900 photograph of the Hughes and Littell families records the beginning stages of butchering. The pork portions such as bacon and chops were divided among the families. Sausage was made by grinding the pork and then placing it in casing with a sausage stuffer. The fat was boiled for lard, and cracklings were the reward at the end of the day.

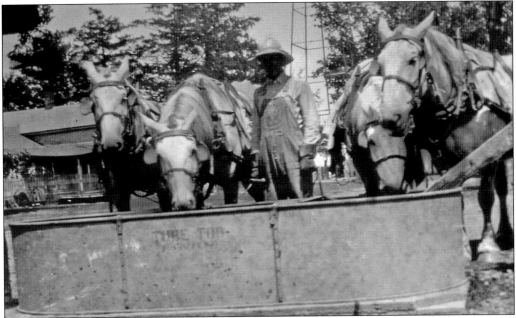

Horses were an absolute asset to farmers until tractors were manufactured. A common sight in early farming days included horses drinking from water tanks, as pictured above at a Ziebarth family farm. (Courtesy of Gary Ziebarth.)

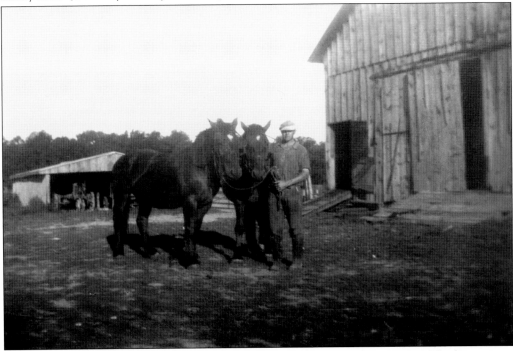

Lloyd Hospelhorn (1914–1987) is shown at his farm northwest of Hudson in 1940. The horses were a wedding present from Lloyd's parents so he and his wife, Oma, could have a farming business. Besides tilling the land, they raised sheep. Their son, Leonard, now farms the acreage, and he and his wife, Sylvia, live on the farm. (Courtesy of Oma Hospelhorn.)

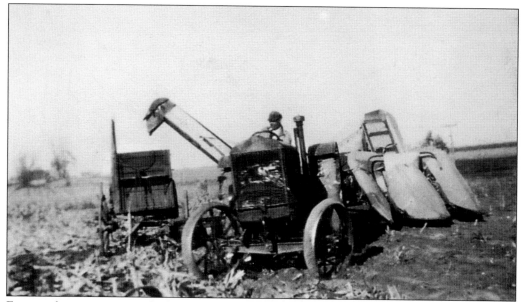

Farming became easier with the invention of farm implements such as the corn picker. In the above image, Fred Humphries is picking corn in the 1930s with a two-row picker. Shown below is an original prefabricated Sears Modern Home purchased by Fred and his wife, Ethel, from a Sears and Roebuck Company catalog in 1927. The house is in Section 16, 0.5 miles north of Hudson. The home kit was shipped to Hudson by railroad, and Humphries then moved the house pieces to their location by a horse-drawn wagon. Originally a one-bedroom bungalow, the house has a bedroom added by Humphries on the north side during the 1950s. James and Judith Hinshaw purchased the home in 1980. The Hinshaws added a two-story addition to the north side of the home. (Both, courtesy of James Hinshaw.)

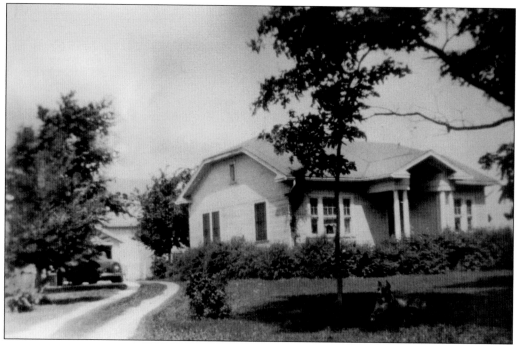

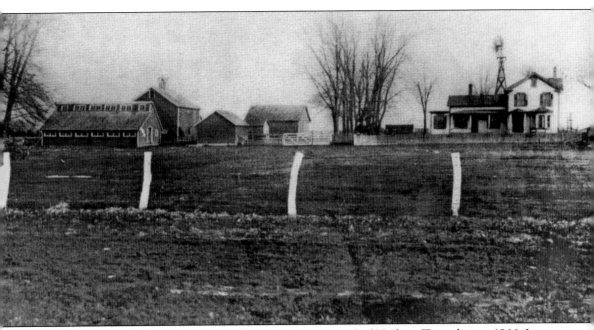

J. H. Burtis and E. E. Burtis purchased 80 acres in Section 15 of Hudson Township in 1866. In 1871, Thomas Humphries purchased the 80 acres at a sale on the courthouse steps in Bloomington, Illinois, for $2,900. Ruth Humphries Cope's great-grandfather built the house pictured here in 1874. In 1887, the land was passed on to Thomas' son, William Humphries. In 1948, the acreage was given to John W. Humphries, son of William Humphries. Ruth Humphries Cope has owned the property since 1965 and currently lives there. This is an early 1900s photograph of the house and farm buildings. A dirt road lies in front of the fence. (Courtesy Ruth Humphries Cope.)

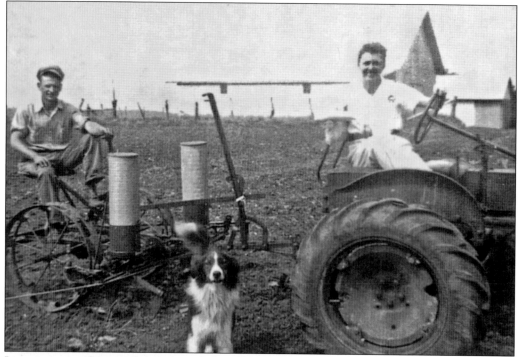

It was necessary for some farmwives to help with agriculture. This late 1930s photograph is of Russell Guthoff (1910 –2001) and his wife, Ruth, farming north of Hudson on the Stiegelmeier farm in Section 15. The Guthoffs also supervised detasselers for H. L. Steigelmeier. Russell played cornet in a band as well, while Ruth was a girls 4-H leader and president of Hudson Home Extension Association from 1954 to 1956. She celebrated her 98th birthday on July 23, 2010.

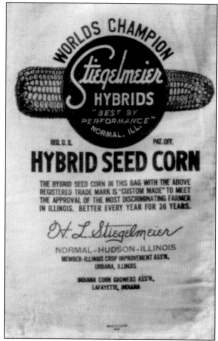

This Stiegelmeier seed bag bears the name of Hudson and Normal, Illinois. Harvey L. Steigelmeier was winner of the Soybean King title four years at the International Hay and Grain Show in 1946, 1947, 1950, and 1955. In the 1950s, he harvested a new record bean yield of 50 bushels per acre on his farm near Hudson.

A familiar scene every summer is that of farmers baling hay. At a Weirman farm in the late 1940s north of Hudson are James Weirman (left) and his brother Gary on a hayrack. Their father, Harold Weirman, is driving the Jeep. (Courtesy of James Weirman.)

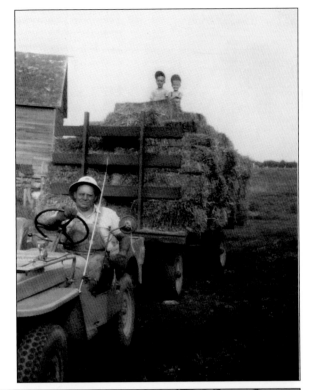

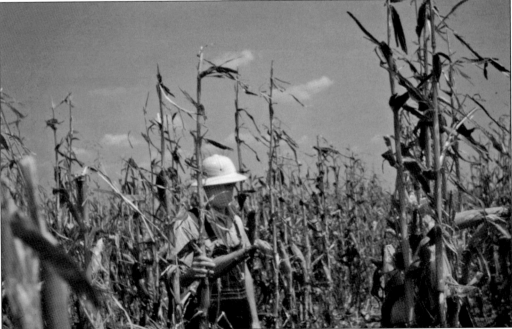

Farmers depend on Mother Nature each year for crop yields. Flooding, drought, high wind, and hail are feared each year. Wayne Stephens is looking at one of his fields that was damaged by hail in 1953. The hail also broke windows out at his house in rural Hudson. (Courtesy of Bruce Stephens.)

The 1948 *Pantagraph* article with the headline "Friends, Neighbors Assist With Hedge Work" is as common in 2010 as it has been for the past 175 years of farming in Hudson Township. In this article, Fred Humphries was severely burned while clearing out hedge and hedge posts. It lists 40 friends and neighbors who helped clear hedge, and notes that women from the Christian Church served lunch.

This group of farmers is pictured in 1953 after plowing for Roy Mauck, who had broken his legs. Mauck lived at the corner of Hudson Road and Pipeline Road. From left to right are (first row) unidentified, Allen Boggs, Albert Marquardt, Otto Allers, and Verlin Schlosser; (second row) Wayne Stephens, Gustaf Ziebarth Sr. (on tractor), Harold Carlock, Roland Cox, Louis Tjaden, Chelsea Harper, Howard McKinney, and William O'Hara. (Courtesy of Bruce Stephens.)

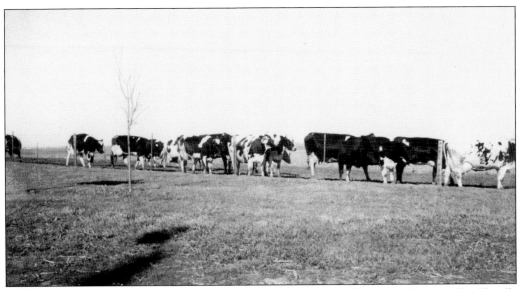

A registered Holstein dairy herd owned by Burdell and Marie Slagell is pictured above. The Slagells owned dairy herds averaging 25 head from 1956 to 1972. At first they separated their milk and sold it in milk cans. In later years, milk was picked up by a bulk tank truck. The Slagells farmed the Shields property southeast of Hudson until their retirement in 1990. All three of their children, Dan, Alan, and Linda, served a term as president of the Hudson 4-H Club and showed Holsteins at the McLean County Fair. Below Dan Slagell is in the farm barnyard with his calf Penny.

Until the 1970s, it was rare not to see chickens on farmsteads. They were raised for both meat and eggs. Donald Whitwood and his wife, Hilda, began raising poultry on a large scale in the 1950s. The above January 1956 photograph shows some of the 1,300 laying hens that were fed in a trough by an automatic conveyor. The hens were also watered automatically. Eggs were gathered, boxed, cased, and placed in a refrigerated storage room twice daily. Although some eggs were sold locally, Whitwood trucked the majority of them to Bowman Dairy in Chicago weekly. To solve a pecking problem caused by some of the chickens, the Whitwoods would catch a chicken and remove its beak. Whitwood is pictured below holding a bag of feed in the chicken house.

William Hasenwinkle operated a grain business and flour mill in 1867. It was destroyed by fire in 1878. Hasenwinkle rebuilt and in 1882 formed a partnership with Charles E. Cox. The partnership dissolved in 1888, and Hasenwinkle's brother Henry became a partner. They established a chain of elevators in central Illinois. The Hudson elevator burned in 1893 and was reconstructed. The Hansenwinkle Elevator Company was sold to Hudson Grain and Coal in 1902. The photograph shown was taken after Hudson Grain and Coal burned in the 1930s.

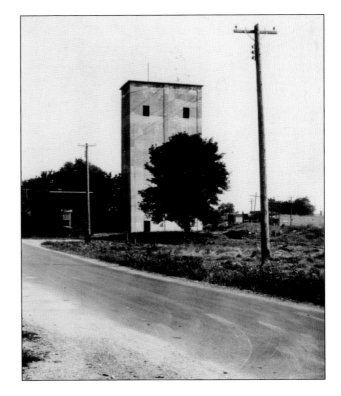

This *Hudson Gleaner* article reports the incorporation of Hudson Grain and Coal Company in 1906. The 1916 business statement lists A. J. Beier as manager. In a 1924 sketch of Hudson businesses, the company's large corncrib held 35,000 bushels. The grain company was located on the south end of Shiner Street west of the railroad tracks. It was destroyed by fire in the 1930s.

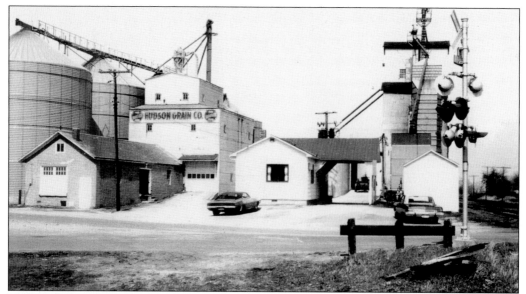

Hudson Grain Company was established in 1933. In 2010, its storage capacity was 2.84 million bushels. This *c.* 1970s image is a view of the Hudson Grain Company. Roger Harper has been the company's manager since 1997. Wallace Francis, Jerry Forsyth, Frank S. Rudisell Jr., Russell Garrett, Joseph Brooks, David Beck, Lester Rudin, Craig Wurmle, Edgar Orr, Dale Bunny, and Harry Carroll are past managers.

Every year since the 1850s, farmers have transported their grain to a grain company in Hudson. Methods of hauling have varied from horse and wagon to tractor and wagon and grain trucks. In 2010, semi trucks are seen among the tractors and wagons waiting to dump grain at the Hudson Grain Company.

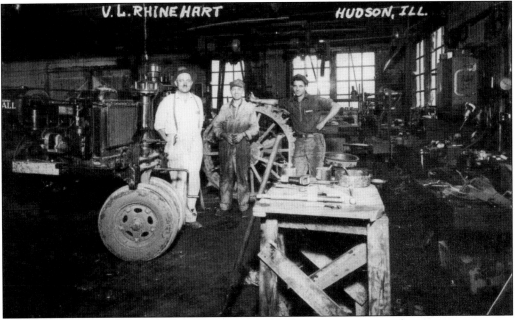

Robert Rhoades and Victor Rhinehart opened the International Implement Agency in the late 1920s. Pictured in 1936 are Rhinehart (left), Hurschel Blough (center), and Earl Kaufman. Up to 1952, owners included Donald Whitwood, Virgil Hinthorn, and Earl Kaufman. Kaufman and Art Kuchan bought the business and started the Hudson Implement Corporation. They sold it in 1977. In 1984, McGrath Incorporated merged with Birkey's Farm Store. Birkey Case-IH purchased the Interstate Center in Bloomington and moved from Hudson in August 2010. The implement building was purchased by Hudson Grain Company. (Courtesy of Hilda Whitwood.)

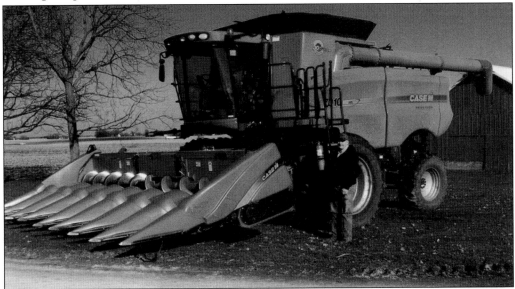

In Hudson Township, with either two generations farming or farming as a business, most farmers work at least 1,000 acres. A few tracts are close to 5,000 acres. Farming machinery is also larger. James Hinshaw is shown with a 2007 Case-IH combine with an eight-row head that also converts to a 36-foot bean platform. Hinshaw is a descendant of the Jesse Havens family.

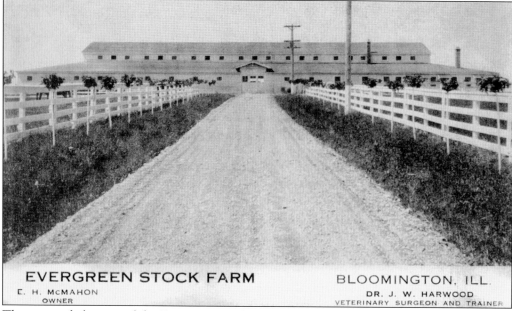

EVERGREEN STOCK FARM

BLOOMINGTON, ILL.

C. H. McMAHON
OWNER

DR. J. W. HARWOOD
VETERINARY SURGEON AND TRAINER

The postcard above is of the Evergreen Stock Farm's building 4 miles north of Hudson. It has been a landmark since the late 1920s. C. H. McMahon owned the stock farm. It was used for winter and summer boarding of thoroughbred racehorses. The building had forty-five 10-foot-by-12-foot box stalls and a 0.1-mile indoor exercise track. The farm advertised 80 acres of bluegrass and clover pasture, 15 three-acre paddocks, and breaking customers' yearlings. All horses were under the personal supervision of Dr. J. W. Harwood, a veterinary surgeon and trainer. Below is a photograph of the recently restored Evergreen Farm building. The original letters were found, refurbished, and placed on the building.

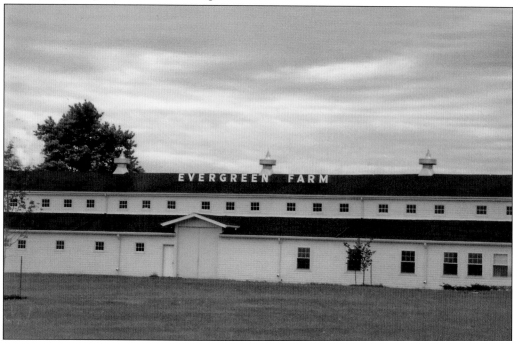

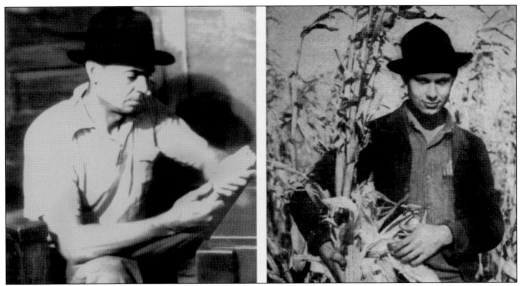

Charles T. Gildersleeve (left) began raising a few acres of hybrid corn for seed in the 1930s. After his son Ben graduated from college in 1940, they formed the Gildersleeve Seed Company. Over 200 farmers attended an open house in 1945 at the Gildersleeve and Son Hybrid Corn processing plant in Hudson. The Gildersleeves began exhibiting grain at the International Hay and Grain Show in Chicago in the 1950s. Their soybeans and shelled corn won the grand champion award three times. Charles received the Bloomington-Normal Ag Club award in 1966 for his years of service to farming.

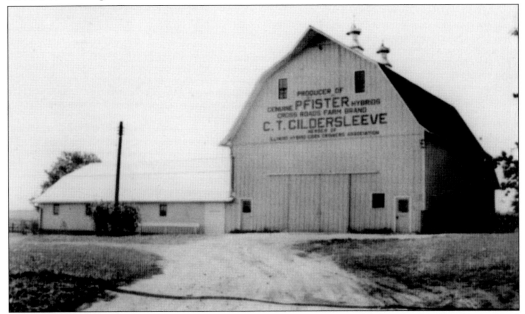

Pictured is the Gildersleeve barn on the farm in Section 26. In March 1968, Gildersleeve Seed Company, Inc. moved into a modern building on the corner of Franklin and Front Streets consisting of a large warehouse, seven offices, conference room, and laboratory. Gildersleeves sold the seed firm to International Multifoods Corporation of Minneapolis in 1977. James, Ben's son, continues with the Gildersleeve farming operation.

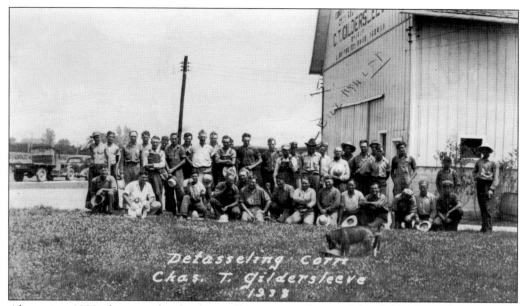

Above is a 1938 photograph of a detasseling crew in front of the Gildersleeve barn. In the summer from the early 1940s to the late 1980s, Hudson and other nearby youth detasseled corn in Gildersleeve's fields. In the latter years, crews operated machinery that completed the detasseling process. Carol Thomas (left) and Rachel Brinkman are shown bagging tassels for hand pollination in August 1965. By 1968, Gildersleeve employed 30 full-time employees and 40 seasonal workers.

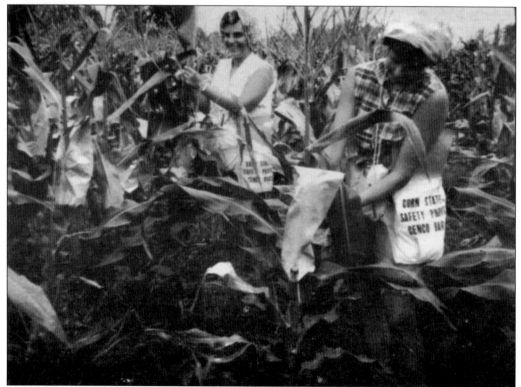

Five

PROTECTING THE PEOPLE

A January 1906 article in the *Pantagraph* states, "The new fire engine purchased by the village board has arrived and has been tested and accepted." In 1906, there was not an organized fire department. An election to form a Hudson Fire Protection District (HFPD) was held 56 years later on May 26, 1962. The proposal was approved, and the first trustees—Thomas Bates, Earl Kaufman, and Edwin Otto—met in June 1962. They appointed Henry Garrett fire chief. Chief Garrett (left) and firefighter John Craig stand beside a new 1963 fire truck pumper.

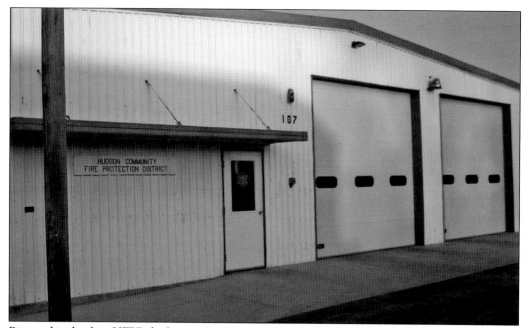

Pictured is the first HFPD firehouse. It was a prefabricated steel 60-foot-by-50-foot building. The lot for the firehouse on Front Street was purchased in 1962 from Ben Gildersleeve. It included a kitchen, meeting room, restroom, and garage for equipment and fire trucks. In 1962, there were 17 volunteer firefighters. Robert Littell served as fire chief from 1963 to 1975. Delmar Thomas was a volunteer firefighter for 37 years, and he served as fire chief from 1998 to 2008.

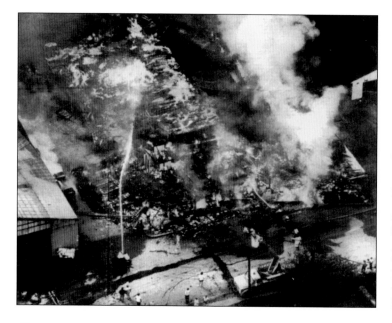

The fire destroying Alexander Lumber Company on Shiner Street in August 1976 was considered the worst fire in Hudson since the 1914 fire on Front Street. Damage to the lumberyard structures and contents exceeded $500,000. Although Alexander Lumber was rebuilt, it closed in 2007 and consolidated with Alexander Lumber in Normal.

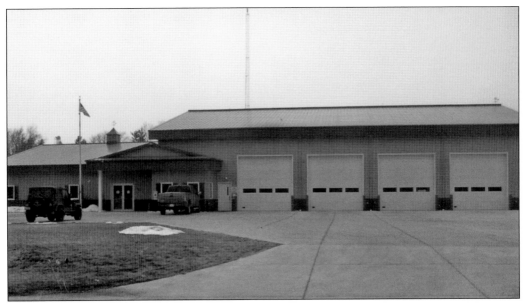

On September 4, 2006, the HFPD broke ground on land donated by Ruth Hamm for an 11,000-square-foot, $1.2-million facility. In 2008, the fire department moved to its new facility on North Broadway. The fire station includes training and meeting rooms, restrooms, showers, and sleeping quarters. The HFPD's 26 firefighters protect 53 square miles, two lakes, and a mile stretch of Interstate 39. To continue emergency medical care, a new ambulance was purchased. There are 14 EMS staff members. The ambulance is staffed 24 hours, seven days a week. The HFPD firefighters and EMS staff in 2010 are pictured below with fire chief Dan Hite (second row, far left).

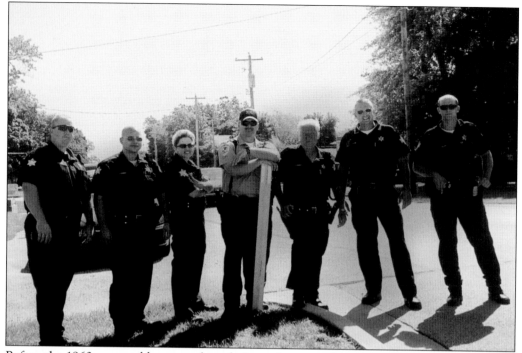

Before the 1960s, constables were elected. According to village records, Doyle Hoffman was the last constable voted into office. Around 1960, police officers were hired and employed by the Village of Hudson. Officers operated out of the water department building until 1996, when they moved into the old bank and library building on Shiner Street. Retiring in June 2006, Roy Garrett had served as Hudson's police chief for 30 years. Hudson's part-time officers, pictured with Garrett (fifth from left) in 2004, from left to right are Robert Collins, Jeffrey Gabor, Chris Gleason, Jeffrey Krietlow (trainer), Michael Lay, and Joshua Saathoff.

Randall Wilson became Hudson's police chief in September 2006. He had served as a sergeant on the Bloomington Police Department since 1993. Wilson retired in 2009, and Hudson native Dale Sparks was sworn into office late that year. The 2010 Hudson police officers are, from left to right, (first row) police chief Dale Sparks, Joshua Payne, and Jeffrey Gabor; (second row) Michael Kemp, Joshua Saathoff, and Robert Brandt.

Village of Hudson trustees have been making decisions and enforcing ordinances for the well-being of citizens since 1870. From a village of 378 in 1899, Hudson has grown as population has increased with the addition of Havens Grove subdivision in 1970 and Prarieview subdivision in 2000 to over 1,900 in 2010. Continuing to keep Hudson a safe and attractive village, village trustees are, from left to right, Allison Brutlag (clerk), Richard Bland, Jason Collins, Mark Kotte (mayor), Kevin Kelley, Betty Scanlon, and David Brutlag. Patrick O'Grady is not pictured.

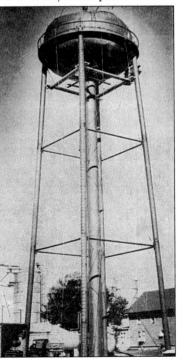

This new water tower with a 100,000-gallon storage tank was ready for use in September 1974. The installation of the bigger tank was expected to meet the needs of Hudson indefinitely. Hudson residents were without water while firemen were fighting a fire August 20, 1974, that destroyed Nevius TV and Appliance on Front Street.

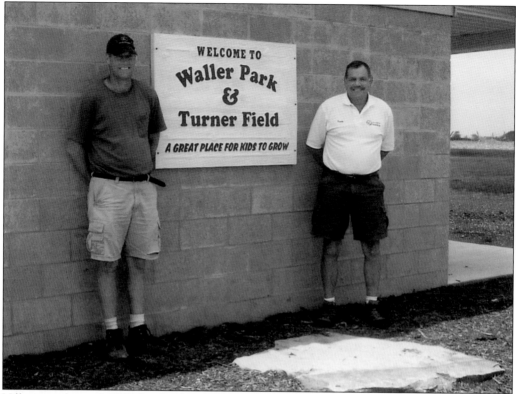

Village employees Jeff Waller (left), supervisor of water and parks, and Frank Heineke, supervisor of zoning and streets, proudly display a new sign for the park and ball field in front of the new concession stand completed in 2010. Heineke has been a full-time employee for the Village of Hudson since 1977.

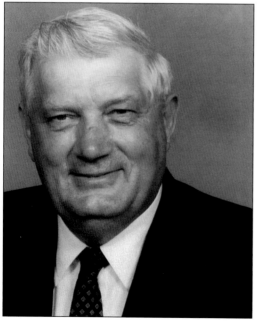

The namesake of Hudson's Waller Park, William "Bill" Waller (1937–1998) moved to Hudson in 1963. His service to the community began by joining the Lions Club in 1965, where he served two terms as president. Along with Lions Club member Jack Cope, Waller was cofounder of the Hudson Little League program. He was mayor of Hudson for four years, a volunteer for the HFPD for 26 years, and the fire chief from 1975 to 1998. Lieutenant Waller was on the Illinois State University (ISU) police force for 30 years, serving as supervisor of the parking department at ISU until 1998. (Courtesy of Lyn Waller.)

Six

FEEDING THE PEOPLE

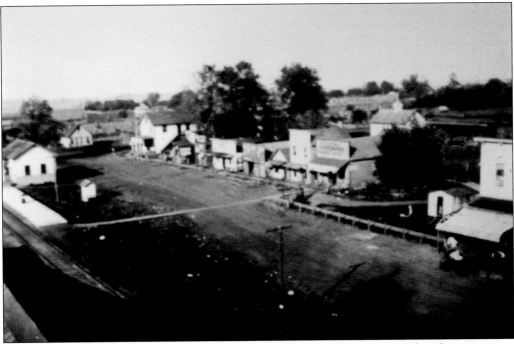

This rare, c. 1905 view of downtown Hudson looks north on Front Street. The white two-story building at the end of the street to the right is the James H. Cox Store built in 1851 as a general merchandise business. The Cox Store at the corner of Walnut and Front Streets operated by James H. Cox beginning in 1851 was one of the first mecantiles selling groceries in Hudson. The Cox Store and the building beside it were destroyed by a fire in the summer of 1914. (Courtesy of Gary Ziebarth.)

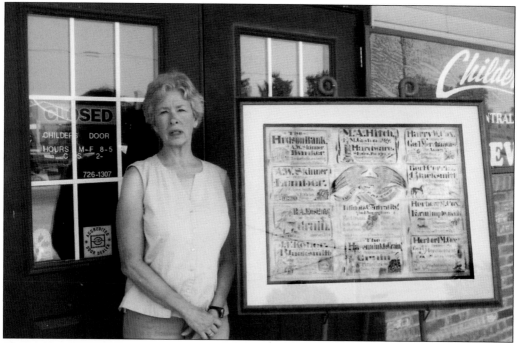

Sharon Cox Quiram, the great-granddaughter of James H. Cox, stands at the corner of Walnut and Front Streets with a sign painted for businessmen in about 1900. Harry W. Cox's name appears in the upper right-hand corner. He and his twin brother operated the store with their father. The sign hung in the Illinois Central depot until 1915 when the station agent, Fred Carrithers, retired and gave it to Fred Snavely. Sharon's father, James H. Cox, bought the sign at an auction and willed it to her.

Harry W. Cox

Staple and Fancy

Groceries,
Dry Goods,
Glass and
Queensware,
Hardware

**Boots and Shoes,
Stoneware,
Tobacco and Cigars,
School Supplies**

This advertisement for the Cox Store, appearing in a 1901 issue of the *Hudson Gleaner*, lists the variety of items offered for sale besides groceries. Another 1900 *Hudson Gleaner* advertises oysters with the following wording: "Oysters, oysters, we have the finest deep sea delicacies fresh from the bottom of the ocean. Will sell by large or small container."

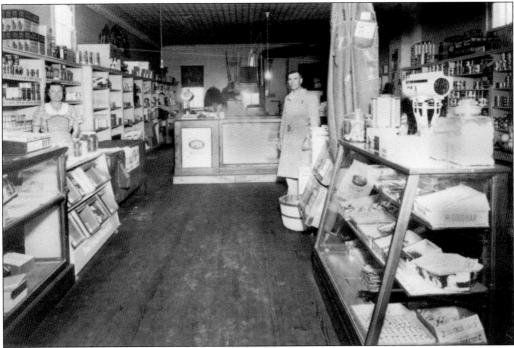

Beginning in mid-1875, a general merchandise store on Shiner Street saw several owners. The Carlock Brothers purchased the store from A. Bistorious in 1878. The store was a bowling alley in 1906. The Snavely Store on Shiner Street, pictured in 1938 above, sold groceries in the 1930s. Prahm Grocery Store, owned by Frank Prahm, was in business in the 1920s until 1929. When Oma Hospelhorn was a little girl in the 1920s, her entire family was quarantined because of scarlet fever. She remembers Frank Prahm delivering groceries to them and leaving the groceries outside. Joseph Guinee, the brother of Eileen Prahm, is shown in front of the grocery in the photograph at right. The Odd Fellows fraternal organization had occupied the second floor of the store since the early 1900s.

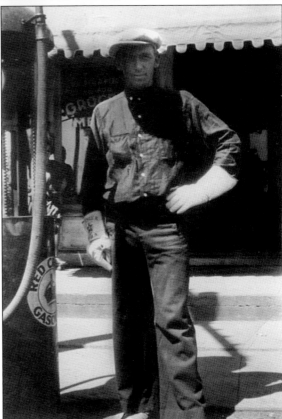

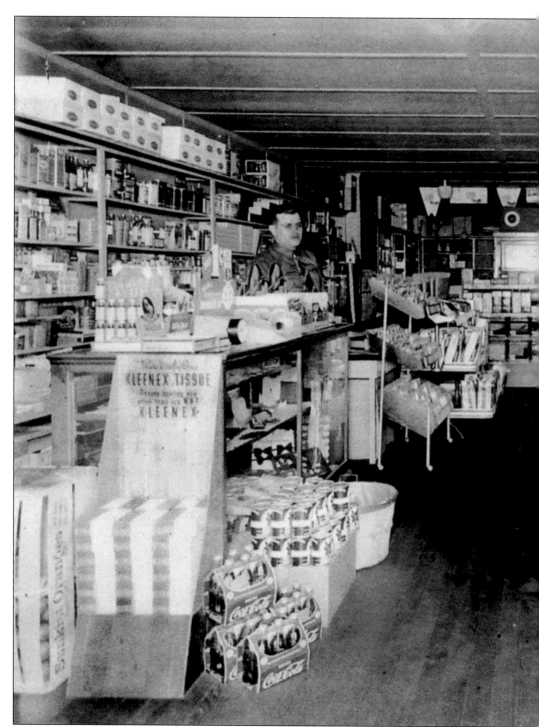

W. P. May erected a pool hall at 113 North Front Street in early 1890. Hurshel Johnson and Bert McNeilly bought the building in the 1930s and opened a grocery store. Shortly thereafter, McNeilly purchased a grocery in Saybrook, Illinois. The Johnson Blue Ribbon Grocery was not a self-serve market. Customers gave their lists to Johnson or a clerk, who then procured the

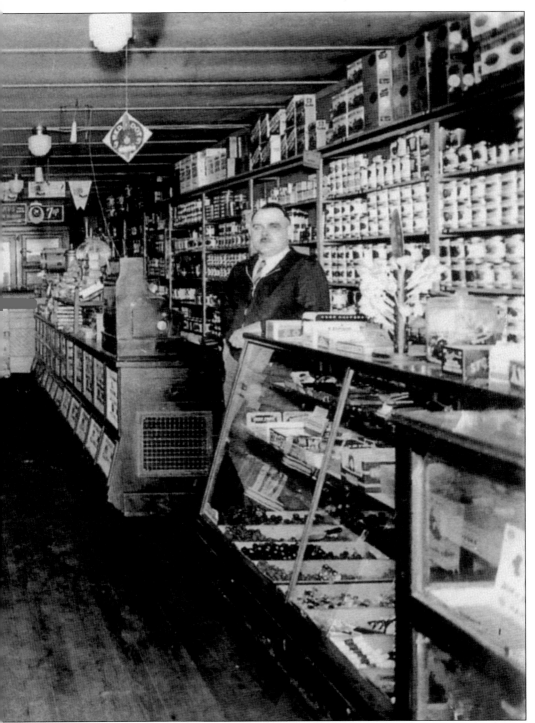

groceries. Pictured are Clinton Thomas (left) and Hurshel Johnson. The enterprise closed in 1950. This is the oldest building in Hudson's business area. Current owners Stephen and Judith Lampert bought the structure in 1984 and operated an antique shop from 1987 to 2008. (Courtesy of Gerald Johnson.)

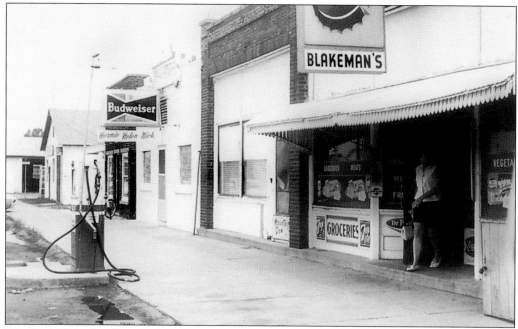

The Paul Blake family moved to Hudson in the late 1940s and opened a grocery store in Prahm's building. About a year later, Blake bought the Hoffman Grocery from the Hoffman family, pictured below. It is currently the Sit 'n Bull Bar on Front Street. This grocery was a self-serve business. When Blake became an insurance salesman, he sold the grocery store to John and Henrietta Blakeman in the late 1950s. Charles Hanson snapped the 1968 photograph above of Blakeman's Grocery as his wife, Jean Hanson, was leaving the store. (Above, courtesy of Jean Hanson.)

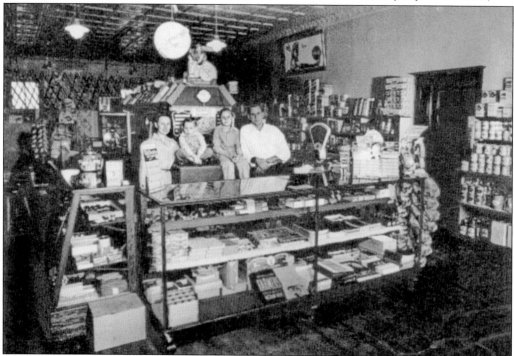

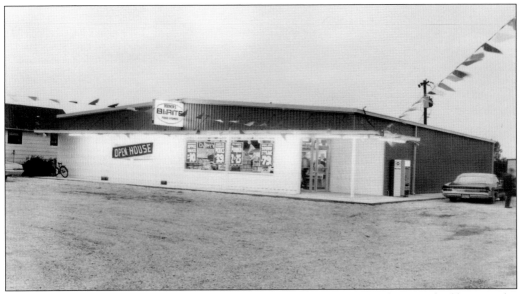

Harry and Frieda Beemer saw the need for a modern grocery store in Hudson. He had been in the food business for 36 years. In July 1966, Vernon Hinshaw constructed a 4,400-square-foot building on South West Street, and the Beemer's leased the building and opened the Beemer Bi-Rite Super Market in the fall of 1966. The photographs above and below were taken the day of their open house. Below Frieda (right) is pictured inside the new grocery. After one year, the Beemer's sold the business to Rodney and Wilma Hoover. (Both, courtesy of Jason Collins.)

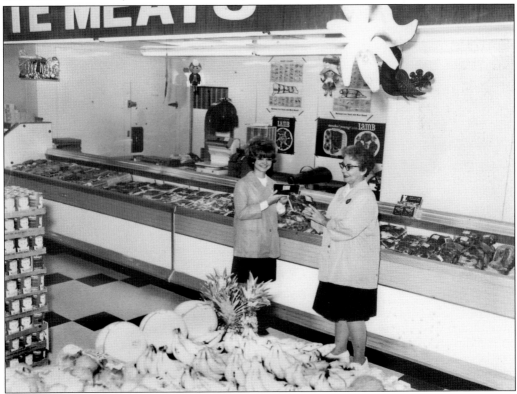

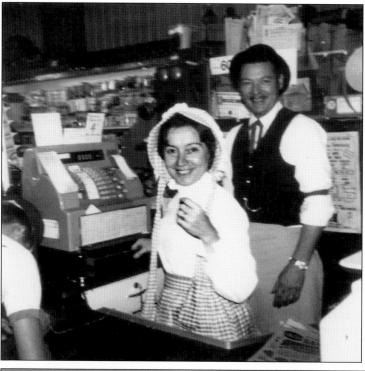

Rodney and Wilma Hoover are pictured in Rod's Bi-Rite Grocery Store during a Hudson celebration. The Hoovers' daughter, Debra, and son-in-law, Charles, were also employees of the store. They bought the business in late 1966 and closed the grocery in 1985. When they ceased operations, Wilma was quoted as saying, "We just couldn't compete with the mega grocery stores that were opening in Bloomington-Normal." Whitwood Construction is the current owner of this property. (Courtesy of Wilma Hoover.)

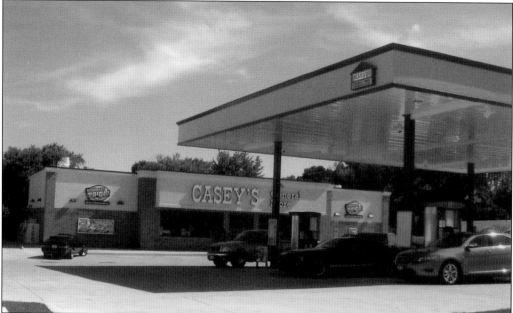

The first Casey's General Store opened in the late 1980s in Hudson on the northwest corner of Franklin and West Streets. Pictured is the new, bigger Casey's constructed on the northeast corner of Franklin and West Streets in 2009. In 2008, to make room for the new Casey's, the house that James H. Cox erected when he came to Hudson in 1851 to open a grocery was demolished. Standing where the Cox house stood in 1851 is the 2010 general merchandise store, which sells grocery staples, candy, fast food, pizza, and gasoline.

Seven

Meeting at the Town Hall

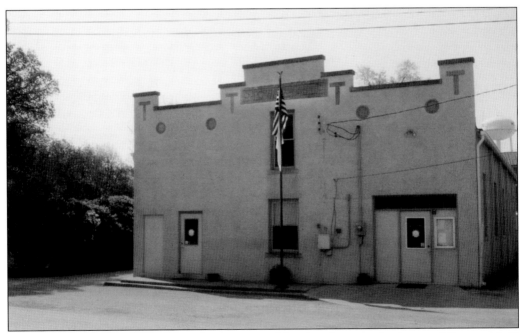

Early public meetings were held at the Seminary School and various businesses. The town hall erected on Walnut Street in 1917 by Hudson Township for approximately $5,000 is pictured above. At an annual town meeting in 1949, residents elected a committee to supervise expenditures. During this time, the building was updated by adding restrooms and renovating the interior. The original structure had a projection room and movies were shown. It remains an active place for meetings, reunions, and fundraising events.

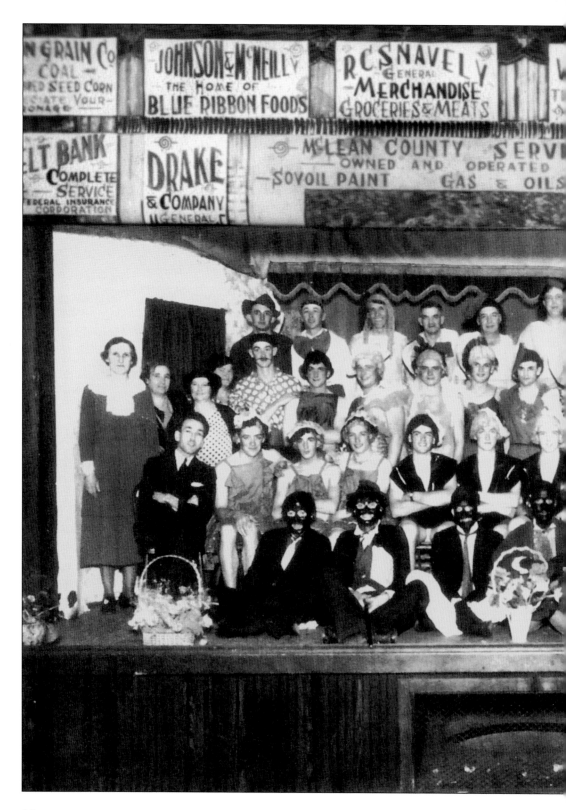

Plays were presented at the town hall in the 1930s and 1940s. The 1932 minutes of the Ladies Aid group of the Methodist Episcopal church state they decided to do something different for a fundraiser by producing a play at the town hall. Their profit was $18.25. The community presented a minstrel show in the early 1930s. Participants of the minstrel show are pictured on the town hall stage. Ardith Jones was the director of this production.

Hudson Township was organized in 1858 with a supervisor, town clerk, assessor, collector, overseer of poor, road commissioners (3), justices of the peace (2), and constables (2) elected April 6, 1858. Today the elected officials for Hudson Township include a supervisor, clerk, commissioner of highways, assessor, cemetery trustees, and four trustees. Current officeholders are, from left to right, (first row) trustees James Hinshaw, Robert Whitwood, Gary Ziebarth, Richard Follmer, and James Birky (retired 2009); (second row) clerk Judith Hinshaw, supervisor Michael O'Grady, road commissioner Vance Emmert, town hall coordinator Barbara Emmert, and assessor Dee Brines.

Alan Rollins is Hudson Township's sexton. In 2000–2001 he, along with Judith Myers, Richard and Sue Keeran, and volunteers, read the entire Hudson Cemetery. The McLean County Historical Society published a book from the readings in 2002 entitled *Illinois McLean County Cemeteries, Volume 21, Hudson Cemetery*. Gary Ziebarth (left) and Rollins are at the gates to the burial ground. The new iron entrance was constructed by the Ziebarth family and installed in 2009.

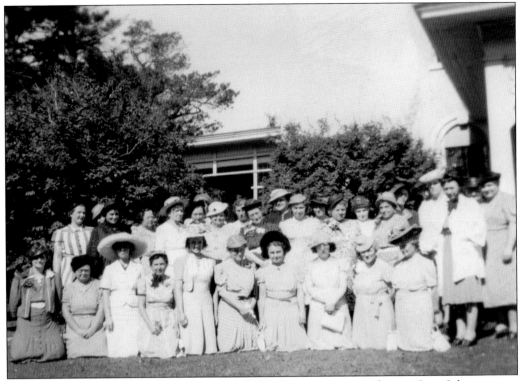

When the Hudson Home Bureau formed in 1918, the women met in homes. Lora Johnston was the first appointed director whose duty was to obtain 50 members from Hudson Township. This photograph was taken at an unidentified member's home in the 1920s. Beginning in January 1944, meetings were held at the Hudson Town Hall. Margaret Ambrose was elected McLean County recording secretary in 1929 and from 1939 to 1941 served as county home bureau president. In 1957 the name of the organization was changed to Homemakers Extension Association. (HEA.)

Ruth Bitting Hamm (1915–2008) was chair of the Hudson Home Bureau from 1939 to 1940 and 1987 to 1988. She was county president from 1959 to 1962. Hamm led the girls 4-H Clothing Club in the 1960s. Besides publishing *Soldiers of the American Revolution Buried in Illinois (1974–1977)*, Hamm authored *The Hudson Colony* in 1976. Hamm's leadership positions in the National Society Daughters of the American Revolution (NSDAR) include vice president general, NSDAR 1959 to 1972, and national chair, membership promotion committee 1995 to 1997. She is listed in *Illinois Lives* and *Two Thousand Women of Achievement*.

The Hudson HEA unit celebrated 60 years on June 29, 1978, at the Cambridge Inn in Bloomington. Charter members in attendance were Margaret Ambrose, Hulda Myers, and Gladys Rhoades. When the Hudson unit formed, members met all day with a potluck meal served. In 1967, they held half-day meetings with a committee-prepared luncheon and the business session and lessons in the afternoon. Five of the officers in 1954 are, from left to right, Gertrude Snavely, Marie Sunkel, Naomi Mauck, Fern Birky, and Ruth Guthoff.

Helen Guth was president of the McLean County HEA from 1967 to 1968. She was chair of the Hudson unit when the name of the organization was changed to Home, Community and Education (HCE). Helen served in that position from 1962 to 1963, 1979 to 1980, and 1999 through 2008. Officers for 1995 pictured in the town hall are, from left to right, Patricia Schumm, Helen Guth, Lena Harper, Elaine Pharis, and Lou Payton.

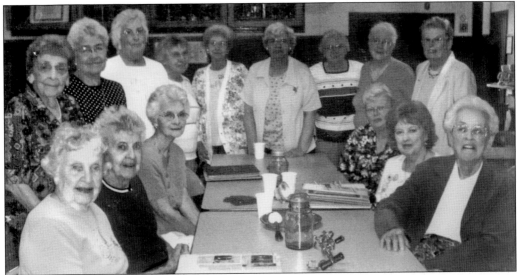

Hudson HCE disbanded in 2008. Those attending the last meeting in June 2008 are, from left to right (first row) Hilda Whitwood, Ruth Guthoff, Marilyn Elvidge, Cherry Trent, Nancy Baumgart, and Ida Stephens; (second row) Hazel Hospelhorn, Helen Guth, Lou Payton, Lena Harper, Patricia Schumm, Elaine Phares, Duvaune Troyer, Florence Uphoff, and Sue Keeran.

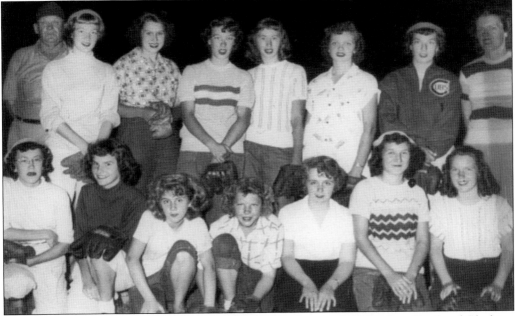

William Myers organized the Hudson Ag 4-H Club for boys in 1929. Hudson Food and Clothing 4-H Club for girls was organized in 1932, led by Ruth Rousey and Hulda Myers. The groups started meeting at the Hudson Town Hall in early 1940. In 1988, the Hudson Ag and the girls 4-H club merged. The 1950 girls 4-H Food and Clothing Club photograph includes, from left to right, (first row) Phyllis Ambrose, Betty Sears, Shirley Boggs, Carol Beverage, Mary Ann Boggs, Lois Bigger, and Patricia Guinee; (second row) Hudson Township road commissioner Gilbert Boughton, Shirley Houser, Dorothy Zimmerman, Ann Birky, Lois Klump, Barbara Gaddis, Mary Snavely, and leader Ruth Guthoff.

Hudson has been represented by several queens and kings at the annual McLean County Fair. Margaret Hinshaw was crowned queen of the McLean County 4-H horse show in August 1943. Those crowned McLean County 4-H queen were Waunita Klump, in the 1940s, and Linda Slagell, 1969. Alan Slagell was king in 1968, and Keith Shiner was crowned king in 1989.

Donald Tjaden showed his Hereford at McLean County 4-H Fair in the mid-1940s. His family also raised Herefords for several years. The Tjaden family started farming in the Hudson area in 1938. Donald lives west of Hudson in Section 20 on one of the farms.

Elaine Harper Swope began her leadership days as president of Hudson 4-H Clothing Club in 1955. She was president of Hudson Junior Woman's Club (HJWC) in 1968, and citizens elected her town clerk from 1969 to 1971. Elaine was elected McLean County auditor in 1976 and served in that position until she retired in 1998. Governor Thompson appointed her to the State Local Records Commission in 1977. While serving as auditor, Elaine was a member of the Illinois County Auditor's Association, where she held the positions of treasurer, secretary, vice president, and president.

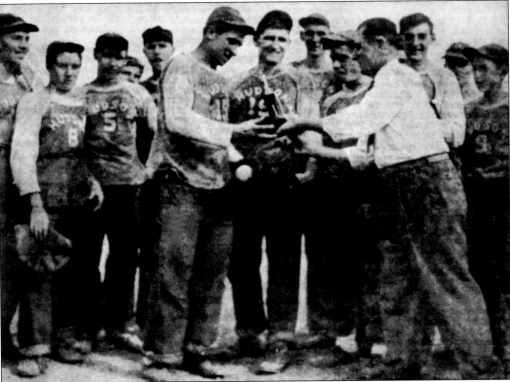

The Hudson Ag 4-H clubs won the state championship in 1934, 1947, 1973, and 1974. The girls won the county championship in 1955, 1956, and 1957. The *Pantagraph* photograph shows Robert Zimmerman receiving the trophy from Clarence Ropp in 1947 after they, as Illinois 4-H softball champions, had defeated the Iowa 4-H champions. Team members in the background are, from left to right, Donald Beverage, Paul Verkler, James Birky, Harold Seigworth, Harold Beverage, Donald Hinshaw, Carroll Dean Shiner, Wallace Francis, Vernon Hinshaw, Norman Verkler, and Russel Bigger. The team played six games in two days. Zimmerman pitched all six.

The Hudson Ag 4-H Club continues meeting in the Hudson Town Hall. The Hudson 4-H clubs have produced several leaders. Hudson members who have served as McLean County 4-H Federation presidents include Roldean Cox, 1955; Linda Slagell, 1960s; and Cary Lampert, 1988. The 2010 4-H members are pictured with leaders Sue Hinshaw (fourth row, far right) and Judith Hinshaw (fifth row, far left).

Eight

CONTRIBUTING TO THE COMMUNITY

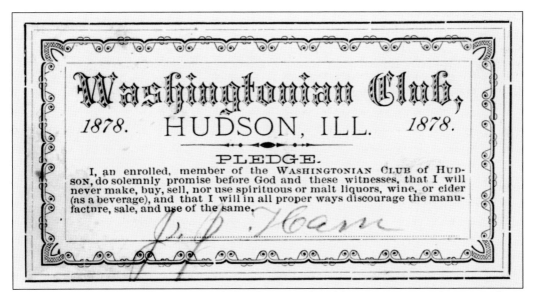

This Washingtonian Club pledge card dated 1878 is the oldest organizational item verifying the existence of a club in Hudson during that time. The pledge is signed by Jacob J. Ham, who arrived in Illinois in 1856. He married Elsie M. Warner in 1859. Their daughter, Nettie Ann, married James Turner Gildersleeve. Ham bought land in Sections 28 and 33, where he had a brick home constructed.

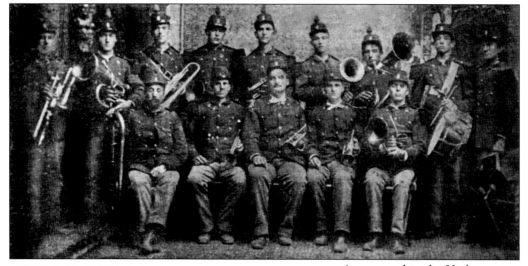

FOURTH

SEMI-ANNUAL

CONCERT.....

GIVEN BY

Hudson Band

✠

ED. H. HAZENWINKLE,
DIRECTOR.

✠

MONDAY, DECEMBER 30,
1901.

As reported in the *Hudson Gleaner*, the Hudson Band was a popular entertainment in Hudson for several years. The 1881 band members pictured are, from left to right, (first row) J. C. Adams, M. M. Shiner, Scott Price (leader for 18 years), Orlo H. Hamm, and John Lawrence; (second row) Solomon Ropp, Knowlton Sailor, Herbert Cox, C. T. Gildersleeve, Harry W. Cox, Aura Johnston, Alfred Ambrose, Asa Skinner, and unidentified. The front of the program pictured at left states, "Fourth Semi-Annual Concert, Given by Hudson Band, Ed. H. Hazenwinkle, Director, Monday, December 30, 1901."

This Antoine Courtois cornet has several inscriptions. Two of these are, "First Prize Gold Medal Moscow Exposition 1872" and "Presented to Harry Owen By the Centenary Sunday school from the Banner Class, June 1877, Edward Hopkins NY." Louis Littell played this cornet in the Hudson Band. Littell's son, Robert Littell, donated the horn and original case to the HAPLD History Room. The family has no record of how the instrument made its way to Hudson.

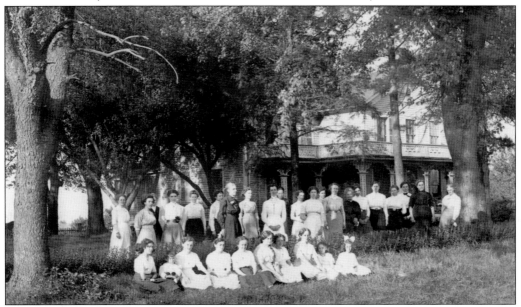

The first General Federated Woman's Club (GFWC) was organized May 2, 1895, with 23 charter members. This 1890s photograph of club members was taken at the home of Etta Havens Carrithers, named Havenhurst, located on the north*east* corner of Hudson Road and Route 51 (now Interstate 39). Since program books are accounted for up through 1918, it is believed the club disbanded during the First World War. Havenhurst was built in the 1860s by Hiram Havens, son of Jesse Havens. The residence was razed in the early 1960s.

September 1, '96	**January 19, '97**
ART—"Madonnas" . Essayist, Miss Stella Morrow	ART—"Elocution" . Essayist, Mrs. Harry Whitmore Cox
September 15, '96	**February 2, '97**
MISCELLANY—"Bridges of the World" Essayist, Mrs. Elijah Houghton	MISCELLANY—"Impurities of the Earth's Atmosphere" Essayist, Mrs. Jennie Smith Lupton
October 6, '96	**February 16, '97**
SCIENCE—"New Sciences" Essayist, Mrs. James Gildersleeve	SCIENCE—"Late Astronomical Discoveries" Essayist, Mrs. Aura H. Johnston
October 20, '96	**March 2, '97**
LITERATURE —"Shakespeare" Essayist, Mrs. Etta Havens Carrithers	LITERATURE—"Victor Hugo" Essayist, Mrs. Mary Ellen Huston
November 3, '96	**March 16, '97**
ART—"American Composers" Essayist, Mrs. Drusa Keller	ART—"Ceramics" Essayist, Mrs. Daisy Garvin Bloomfield
November 17, '96	**April 6, '97**
MISCELLANY—"Relation of Literature to Society" Essayist, Miss Loretta Johnston	MISCELLANY—"Our System of Government" Essayist, Mrs. Herbert M. Cox
December 1, '96	**April 20, '97**
SCIENCE—"Achievements in Engineering in last half Century" Essayist, Mrs. Chas. Dunlevy	SCIENCE—"Study of Heredity" Essayist, Miss Jessie M. Holder
December 15, '96	**May 4, '97**
LITERATURE—"Napoleon" . Essayist, Mrs. Ira J Barsby	LITERATURE — "Colonial Women" Essayist, Mrs Cora Gastman
RECEPTION January 5, '97	BREAKFAST May 18, '97

Hudson GFWC's motto was Progress Along All Lines. As noted in this 1896–1897 Hudson Woman's Club program, club members educated themselves by writing and performing various presentations. Other outlines list talents shared by the members. In 1902, Saidee Gray Cox was a candidate for the presidency of the state GFWC. She had served as GFWC state secretary.

In 1967, the General Federated Hudson Junior Woman's Club (HJWC) was formed. The first meeting was May 1967 at the Hudson Town Hall with 36 charter members. Shown in this 1968 photograph are the first president, Linda Webel (left), and Elaine Swope, the second president. Club projects the first years included sponsoring a children's story time, drug abuse programs, and Red Cross bloodmobile. The latter is a continuing project.

Pictured at the Hudson Town Hall is Shirley Vertrees, who was the force behind the girls softball program in 1972. At the urging of Vertrees, the HJWC started sponsoring the program in 1974. An article in the July 25, 1974, edition of the *Carlock Chronicle* reports, "It used to be that only boys played at the ball park in Hudson. Now on Monday night in Hudson, the girls are on the field playing. Now that's 'Women's Lib.'"

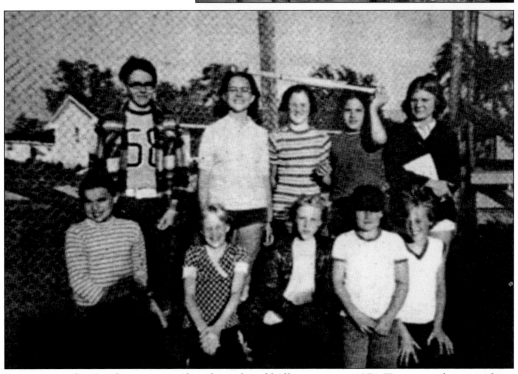

Approximately 45 girls participated in the girls softball program in 1974. Team members are, from left to right, (first row) Kathy Carmichael, Debra Whitwood, Angie Grogg, LeeAnn Vertrees, and Cindy Whitwood; (second row) coach Dianne Garrett, Peggy Alvis, Cynthia Lipscomb, Brenda Beal, and coach Debra Payton. Members on the team not pictured are Brenda Thomas and Mindy Brucki. Since the inaugural year, 55 to 70 girls participate in the summer ball program each year.

The first concession stand used by HJWC in 1967 came from Jones' Lake 5 miles northwest of Hudson where Comlara Park campground is located today. Ardith Jones operated the lake for fishing and concessions from 1955 to the 1960s. Selling concessions at the summer ball games has been the club's major fundraiser. New stands were built in both 1983 and 1997 and used through 2009. In 2010, under the direction of Village of Hudson employees, volunteers donated labor and materials to build a modern concession with restrooms, dugouts, and a new field.

HJWC started sponsoring the Super Seniors in 1980. The Super Seniors met monthly, with HJWC providing meat for their potluck. Bingo prizes were awarded to seniors each month. Each year, Hudson Township and the Village of Hudson contributed financially to this program. The annual Christmas party and June picnic were favorite events of the seniors, with HJWC furnishing the food and entertainment. Sitting at the first table at a Christmas party are, from left to right, Ethel Weirman, Oma Hospelhorn, and Emma Swope Stoutenborough.

The last Super Senior meeting sponsored by HWC was in June 2010. Pictured in the Hudson Town Hall at the last meeting are, from left to right, Mary Beth Tobin, Sue Keeran, Connie O'Grady, Mida Fehr, and Beverly Stotler. Keeran, Tobin, and O'Grady were the coordinators of the Super Senior meetings for 30 years.

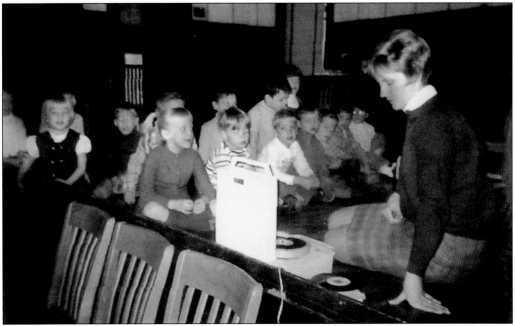

Without a library until 1980, story hours were sponsored by HJWC. Lois Whitwood is shown reading to children at the town hall in 1970. Lois was HJWC president from 1976 to 1978. HJWC started a lending library in 1978. Books were stored at the town hall, and club members would set up tables with donated books for children to check out on Saturday mornings.

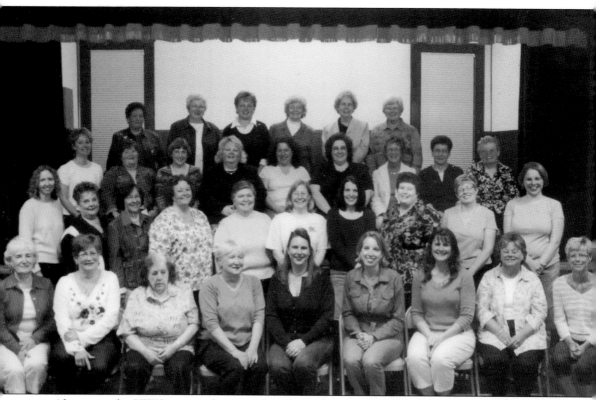

Above are the HWC past and present members who attended the club's 40-year celebration in April 2007. HJWC voted to drop the "Junior" and change to HWC in 1987. Babysitting clinics, lunch with Santa, girls softball, Super Seniors, and the launch of the volunteer library in 1980 are just a few of their service projects over the past years. Desiring to focus on local programs, the club disbanded from the GFWC in 2004 and continues sponsoring programs to benefit Hudson.

The handwritten document reads:

Hudson Mens Club.

The first mens meeting of the men of the Hudson Community was held at the home of Mr. James H. Cox. After an outdoor supper of weiners, steak, hamburger sandwiches, coffee, cake and marshmallows we entered the house where the meeting was called to order by Jas. Ambrose. 12 men present. Motion made seconded and carried that the name of the organization be the Hudson Mens Club.

Mr. Ellison read a constitution and by laws which he had drafted. It was decided as best to vote on each article separately. It was moved and seconded that the first section of the bylaws be adopted as written. Motion Carried.

Moved and seconded and carried that any man of high school age or over may be a member.

Moved and seconded and carried that officers as set forth by the bylaws be elected; to consist of Chairman, Vice Chairman and Secretary-treasurer. Motion made and seconded and carried that the officers be elected semi-annually. Motion made and seconded and carried that meetings be held monthly.

By ballot: Rev. L.E. Ellison, was elected chairman; James B. Ambrose, vice chairman; and Claude H. Cox secretary-treasurer.

Moved and seconded and carried that chairmen of the various committees be accepted as recommended by the nominating committee. Moved, seconded and carried that the third Wed. night of each month be the regular meeting night. Next regular meeting to be held the third Wed. night in November. A special meeting to be held at the home of Robt. Rhodes on Oct. 16th. An initial offering was taken and it amounted to $1.34

Chairman of Program Committee Edward J. Hamm.
" " Civic " Park Eicher.
" " Religious work " Joe Gildersleeve.
" " Publicity " Fred Seigworth.
" " Finance " Bernard Ambrose.

Judson Ambrose, Secy. Pro. Tem.

Articles in the *Hudson Gleaner* document that there were men's organizations in Hudson in the 1890s. The Odd Fellows met in the second story of the Prahm Grocery and Snavely Grocery on Shiner Street. Hudson Men's Club (HMC) minutes show the club was organized in September 1940. HMC was responsible for the Veterans Memorial in Veterans Park. There are no HMC minutes after March 1948.

HUDSON LIONS CLUB
CHARTER NIGHT BANQUET
EAST BAY CAMP LAKE BLOOMINGTON
JUNE 27, 1964 6:30 P.M.
PRICE $2.75

- OFFICERS -

President	Dean Helm
1st V. Pres.	Joe Wilson
2nd V. Pres.	Frank Rudisell
3rd V. Pres.	Bill Schroeder
Secretary	Jerry Hillhouse
Treasurer	Jack Cope
Tail Twister	Carl Burress
Lion Tamer	Roy Mauck

- DIRECTORS -

Wayne Downen Fred Snavely
Everett Quiram
Earl Kaufman

- CHARTER MEMBERS -

1.	James Ambrose	26.	Delbert Nevius
2.	Farrell Bagshaw	27.	Philip J. O'Leary
3.	Paul Blake	28.	Douglas Otto
4.	John Blakeman	29.	Dennis Otto
5.	Carl Burress	30.	Edwin Otto
6.	John Cable	31.	James Price
7.	Jack Cope	32.	Everett Quiram
8.	Paul Cope	33.	Ed Raycraft
9.	Jack Craig	34.	Frank Rudisill, Jr.
10.	Wayne Downen	35.	Charles M. Sanders, Jr.
11.	James Hamm	36.	William Schroeder
12.	Thomas Hardwick	37.	Louis Sila
13.	Donald Harper	38.	Harry Silvey
14.	Dean Helm	39.	Fred Snavely
15.	Dean Henderson	40.	Floyd Starkey
16.	Jerry Hillhouse	41.	Keith Starkey
17.	Vernon Hinshaw	42.	Loren Starkey
18.	Earl Kaufman	43.	Riley Starkey, Jr.
19.	Joe Kimmons	44.	Wayne Stotler
20.	Kenneth Koons	45.	Wendell Stotler
21.	William Koons	46.	Jack Streeper
22.	Clifford Lawrence	47.	Harold Weirman
23.	Harold Lipscomb	48.	Orn Whitacre
24.	Roy Mauck	49.	Joseph Wilson
25.	Donald McWard	50.	Loyal Wood

The first organizational meeting for the Hudson Lions Club was held on April 13, 1964. At the Charter Night Banquet at East Bay Camp on June 27, 1964, fifty charter members joined the club. Pictured is an event program that lists the charter members.

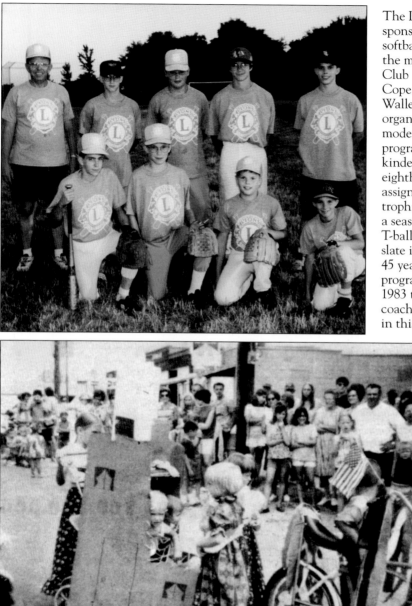

The Lions Club started sponsoring summer softball leagues around the mid-1960s. Lions Club members Jack Cope and William Waller were the organizers of the modern boys softball program. Boys from kindergarten through eighth grade are assigned to teams, and trophies are awarded at a season-ending party. T-ball was added to the slate in the 2000s. After 45 years, this successful program continues. A 1983 team poses with coach David Brutlag in this photograph.

Beginning in 1963, the Lions Club sponsored the Hudson Lions' Festival each summer. The festival's name was changed to Hudson Prairie Days in the early 1980s as organizations and churches began helping with the festival. The summer attraction always included a parade, children's games, food, and evening entertainment. A children's parade in July 1971 on Front Street is pictured here. The festival was discontinued in 2008.

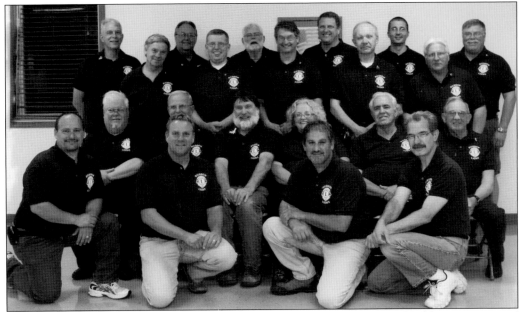

Besides the boys softball little league in the summer, Hudson Lions collect eyeglasses for international distribution to the poor and annually sponsor an Easter egg hunt, lunch with Santa, and a Halloween spook house. The above Lions Club members pose for a photograph in 2010. There are a total of 27 members.

A Boy Scout troop continues to be active in Hudson. In 2010, Boy Scout Troop no. 57 with 23 members meets weekly at the Hudson United Methodist Church. The scoutmaster is Daniel Augustine. Bryce Stremming, Paul Amundson, and Anne Portz are assistant scoutmasters. This February 1971 (Boy Scout Month) photograph is of Cub Scouts from Den 3 of Hudson's Pack 57. Scouts taking up collection at the Hudson Christian Church are, from left to right, Robert Koons, Dale Whitwood, Timothy Moore, Roger Harper, and Brett Starkey.

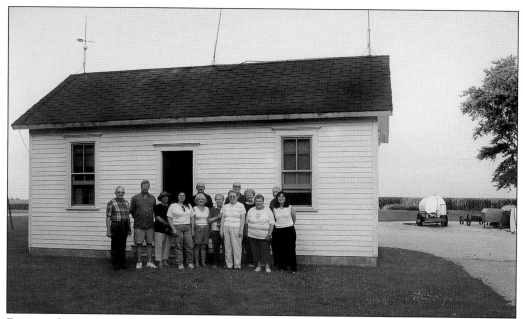

Five people attended the first meeting of the Hudson History Club (HHC) in 2001. The main function of the club is collecting, preserving, and sharing the history of Hudson. Since HHC's initial meeting, members have organized several thousand items. Photographs of schools, churches, and organizations; obituaries; books; census records; and artifacts are some of the items accessible to the public. HHC members pose in front of the renovated 1895 Myers house.

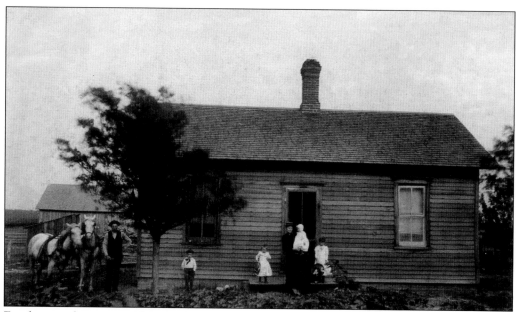

For the past three years, HHC has toured several older homes in the village of Hudson and rural areas that have been preserved. The 1895 Clinton and Ora Belle Myers house still stands on the Wayne Stephens farm northeast of Hudson. Wayne's son, Bruce, renovated the house. Members of the Myers family are, from left to right, Clinton, William, Tima, Ora Belle (holding Nora), and Edith.

Nine

PROVIDING WATER AND RECREATION

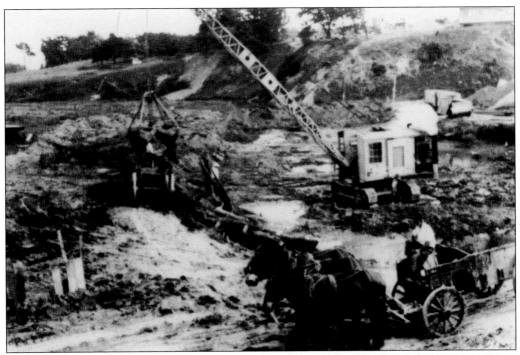

A combination of water shortages, foul water odor, and waterborne sickness led to the building of Lake Bloomington in 1929. In 1925, a group of 14 citizens studied water supplies. Citizens Water Supply Company, Inc. was formed in 1927. The committee became stockholders, and additional members increased the number of stockholders to 25 with each paying $75,000. The name changed to Bloomington Water Company (BWC). This mule team was used during the construction of the lake.

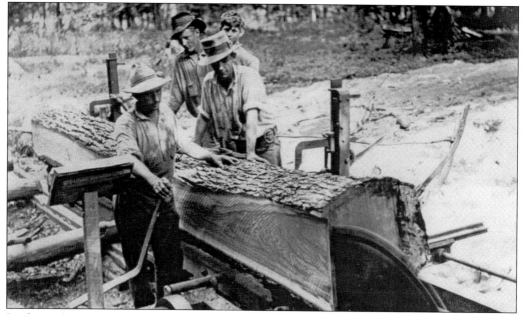

In the early spring of 1929 there were over 50 woodsmen clearing the land for the lake and spillway. It was estimated that 40,000 to 50,000 trees were felled for the lake project. Cast Stone Construction from Wisconsin was awarded the contract to clear the land, and several men from the area were hired to help. Local men shown planing lumber are, from left to right, Emmitt Hinthorn, Omar Vandegraft, Bo Platt, and John Boinett. Springwater was used to cool the hydraulic saw. (Courtesy of Arthur Kuchan.)

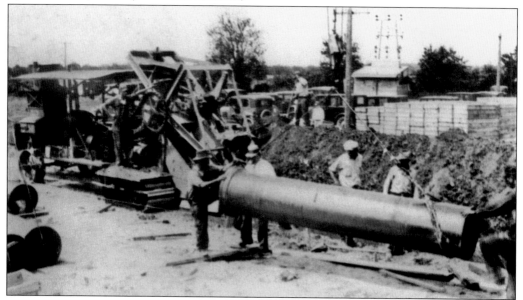

Money Creek northeast of Hudson was chosen as the water supply for the lake. With a bid of $925,000, J. L. Simmons won the bid to construct the body of water. BWC bought approximately 1,278 acres of land by deed or contract. Purchase price ranged from $90 to $165 an acre. In the above photograph, men are shown laying water pipe to Bloomington. The lake and distribution system began delivering water to the City of Bloomington in April 1930.

Pictured is a map of Lake Bloomington. It was stated at a 1930 BWC meeting that 500 acres are submerged in the lake and 800 acres are marginal land with native trees and park space.

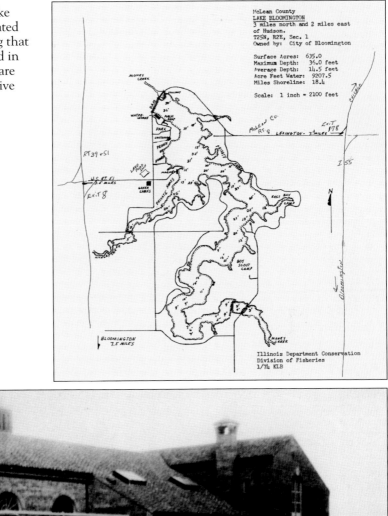

To complement the beauty of the lake, the pumping plant, shown here after its completion, was constructed in September 1929 in "Rural Italian" style. Charles Spaulding, chemical engineer for the facility, told BWC that it was one of the finest in the land for its size. When the City of Bloomington made a final settlement with BWC in December 1931, the company was liquidated. The sum of $1,153,856 had gone to the construction of Lake Bloomington.

The Hubbard Gate was built at the original entrance to the pumping plant. It is located just south of the current road to the pumping plant. In 1931, the Hubbard family held a reunion in Hudson to present a plaque in honor of Dr. Silas Hubbard. The plate was affixed to the south stone of the Hubbard Gate at Lake Bloomington. It contains a bas-relief of Hubbard that was executed by Jerome Conner, a celebrated sculptor in the 1920s and 1930s.

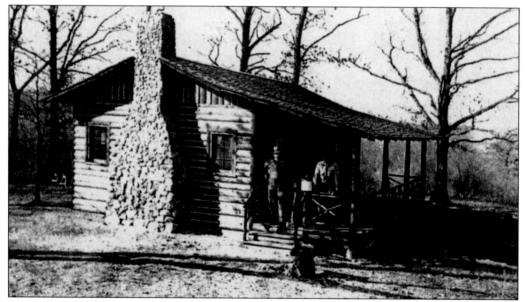

In March 1930, engineers submitted a plan for marking out cottage lots at the lake. By July 1930, six lake cottages were being constructed. Leland C. Sherrill remodeled a country cottage and moved it to the lake. Sherrill's cottage was the first at the lake. It consisted of a 26-foot living room with a fireplace, two other rooms, and a 530-square-foot screened area. This early 1930s log cabin was built by Hurschel Johnson (left) and Charles Masincupp in the Camp Iroquois area. They sold it to Earl Kaufman in late 1950. It has since been razed. (Courtesy of Gerald Johnson.)

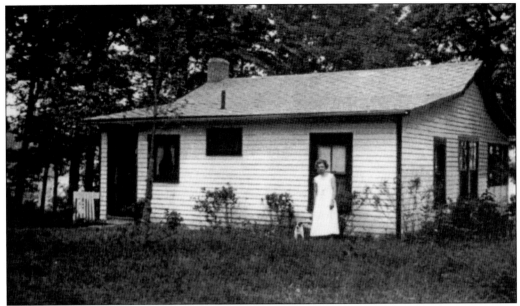

Most lots at Lake Bloomington were sold for $100 to $300 in the 1930s and 1940s. The Boise family from Gridley were the original builders of the cabin pictured. Vernon and Mildred Burtis owned the cabin around 1936. Mildred is shown in front of the cabin in 1937. The Burtis' son, Lewis, sold the residence. (Courtesy of Carman Burtis Gresham.)

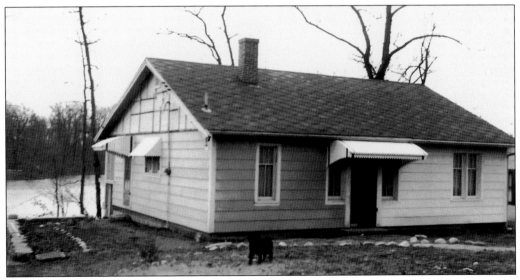

James and Fay Guinee moved to this cabin in 1945. The house was updated in 1959. It is located in the Camp Potawatomie area on the west shore of Lake Bloomington. (Courtesy of James Guinee.)

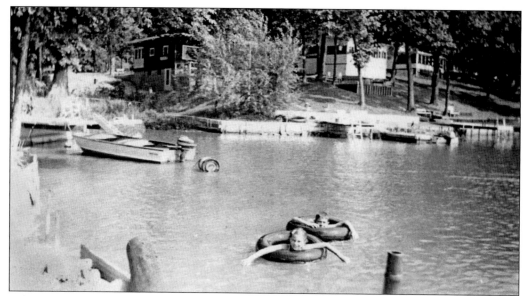

Lake Bloomington property owners met in April 1950 to form an organization to protect their interests and to promote the lake. This was the beginning of the Lake Bloomington Association. John Rodgers III of Bloomington was elected the group's first president. In this mid-1950s photograph of the Cloyd Stahly lake home, children enjoy one of the recreational benefits of living at the lake. From spring to fall, residents and visitors enjoy the water by cruising in pontoon boats, water-skiing, and fishing.

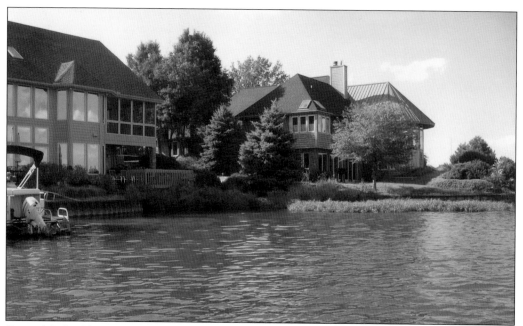

Several Lake Bloomington residents began staying at the lake year-round in the 1970s. The waterfront was a desirable location for a permanent home, and therefore, real estate prices steadily rose. Today there are several beautiful homes with values of $300,000 to over $1 million. The pictured home located on Eagle Point was built in the area of the original public beach.

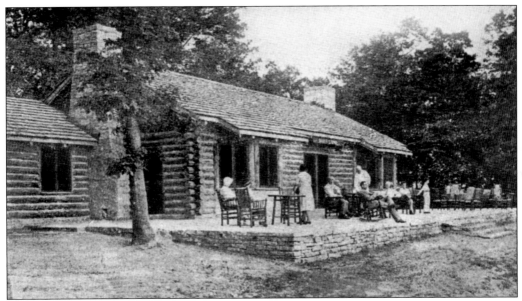

Dedicated in June 1932, a public pavilion at Lake Bloomington was named Davis Lodge in honor of the late H. O. Davis. He devoted his efforts to the provision of a water supply for the lake. The log lodge was built for the public with a 25-foot-by-45-foot main room with fireplaces at each end. It had a door leading out to a 20-foot-by-65-foot terrace. Also included were a screened porch dining area, women's restroom, kitchen, and a delivery porch. The Davis Lodge is pictured the day of its dedication. (Courtesy of the *Pantagraph*.)

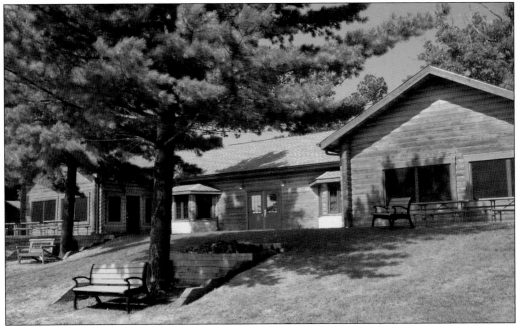

Because of deterioration in several areas, the City of Bloomington razed the Davis Lodge in the late 1990s. The two original stone fireplaces were saved. The lodge was rebuilt with the same rustic look, and it was updated with heating, air-conditioning, and an expanded kitchen. The lodge reopened in 2001and is rented to the public for special events.

A new bathhouse at Lake Bloomington was under construction in June 1934. The building of paving brick was 18 feet by 75 feet, and it had a central two-story section that was used as the checking room. This was a relief work project. A *Pantagraph* July 25, 1935, article announced that the recreational facilities of Lake Bloomington were to be in full swing by the weekend. Lifeguard Oliver Allyn is pictured beside the original bathhouse in 1947. It was referred to as the beach house in the 1940s and 1950s. (Courtesy of Edgar Lundeen Jr.)

There was a controversy in the 1930s with charging 10¢ for the public to swim. Pictured are the dock and swimming area looking east toward the lake in the late 1940s. Although the beach was closed during World War II, it reopened in 1946.

Beginning in the summer of 1947, a group of college-age friends formed an independent business that made a successful bid of $150 to the City of Bloomington to operate the swimming beach and concessions. The friends are, from left to right, John Marquis, Edward D. Tertocha, and Edgar Lundeen Jr. Following is a quote from Lundeen: "We charged 25¢ to swim, and we had 1,000 people on one hot weekend." Polio cases caused the beach to be deserted each year in August, but it stayed open until Labor Day. The beach closed in 1958.

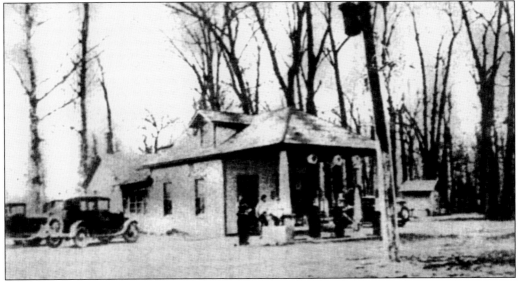

Green Gables is pictured around 1930. John Hinthorn opened the business as a gasoline station in 1930. Other Green Gables operators were Riley Starkey, Keith Starkey, and Elmer Swearingen. Ross and Marilyn Elvidge purchased the small grocery and gas station in 1952 and added a restaurant. The gasoline pumps were removed after the 1970s.

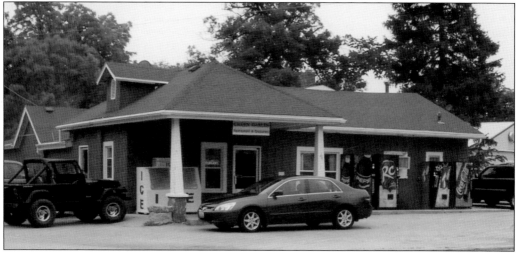

Green Gables stayed in the family after Ross Elvidge's retirement in the late 1980s. His daughter, Julie MacPherson, and her husband operated it for seven years, and after that, another daughter, Sandra Holder, and her husband, Michael, bought the business. The Holders continue as owners. McLean County residents continually vote Green Gables' cheeseburgers as the best in the county.

The Lake Road Inn was constructed in 1933 by Samuel Anderson, who sold the business to his son, William Anderson, in the mid-1940s. The establishment was purchased by Jack Graybill as a tavern in 1975. Graybill doubled its size in 1985 and added a kitchen. He then offered lunch and dinner along with the bar. Terry Harris trained as manager of Jack's Lake Road Inn before taking over as owner in January 2005. The Martin family operated the inn a few years, and Graybill returned as owner in 2010.

East Bay Camp was founded by Rev. Frank Breen in 1929. Breen's idea behind East Bay Camp was to provide a place in which children could enjoy Lake Bloomington without their parents having to own a cabin. Some of the early cabins were built with lumber salvaged from the Chicago World's Fair of 1933–1934. Elizabeth Weir of Lake Bloomington was camp manager during Breen's tenure. East Bay is on the eastern shore of Lake Bloomington.

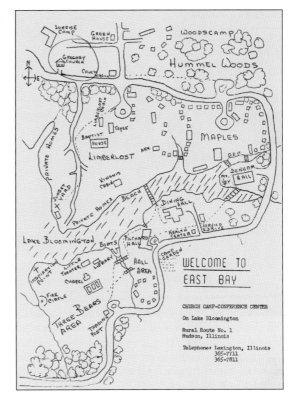

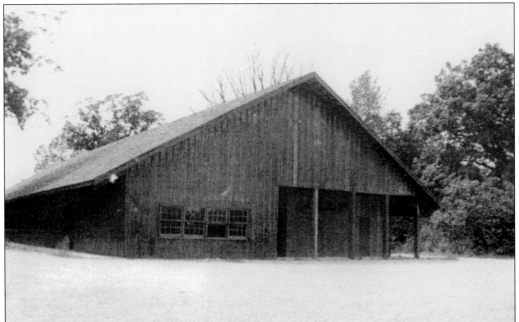

East Bay Camp's first building, the dining hall with a capacity of 550, was erected in 1930. A service building, camp infirmary, and staff houses were built next to it. In the booklet *Story of East Bay Camp-Lake Bloomington* by Tom Gumbrell, he writes that within 33 years there were more than 200 buildings at the camp.

The dining hall constructed after destruction of the first dining hall was divided into main, north, and south halls and a tea room. Not far from the dining hall is Pilchard Hall, a year-round dormitory. This hall was named for Edward Pilchard, a Methodist layman who planned the Maples camp as a starting place for all 4-H Club activities in Illinois.

Standing in front of a cabin at East Bay Camp named Lemon Drop Kids Cabin is Mida Knapp Fehr of Hudson. The photograph was taken while she was attending a Future Homemakers of America retreat in the 1950s. Numerous camps sponsored by different groups continue to be held at East Bay. The East Bay Camp area is currently owned by the Central Illinois Conference of the United Methodist Church. (Courtesy of Mida Fehr.)

Sponsored by the Easter Seals Society of McLean County and ISU, children with physical disabilities from McLean County and around the state of Illinois have been served since 1949 by Camp Heffernan at Timber Pointe. The Easter Seals Rehabilitation Center serving Fulton, McLean, Peoria, Tazewell, and Woodford Counties purchased Camp Heffernan from the Boy Scouts in 1988. Pictured above is the new multipurpose building constructed in 2006. Below is the boating and swimming area for the campers.

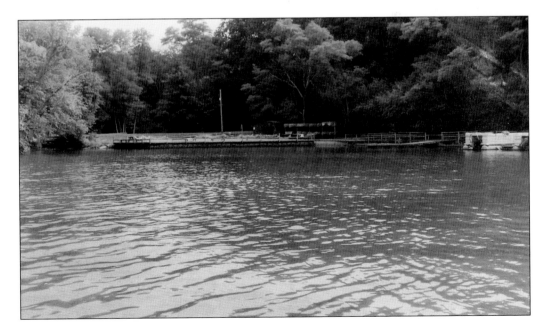

In the early 1970s, Chaunce Conklin presented plays at the Little Theatre in the Three Bears area at East Bay Camp. The pictured program gives information regarding the play being presented in July and August 1971. Conklin eventually moved his theater to a huge barn in Goodfield, Illinois. The Little Theatre at East Bay no longer exists.

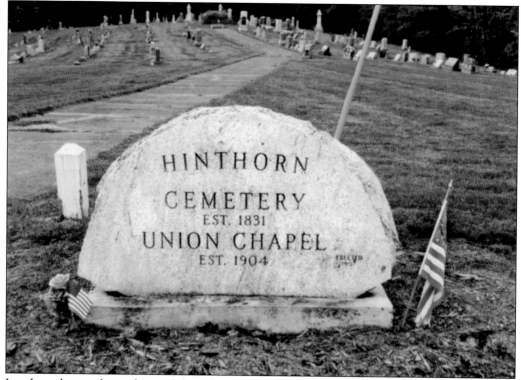

Land on the southern shore of the lake was donated by William Hinthorn for the Hinthorn Cemetery in 1831. Other history records the names of Jacob Hinthorn, Jackson Vandegraft, John Aldrich, and Charles Cox as donors of land for a free cemetery. Dorothy Anderson Stewart, great-great-granddaughter of William, a Hinthorn trustee, reports that 75 percent of those buried in Hinthorn Cemetery are relatives. The Hinthorn-Union Cemetery Trustee Board was organized in 1921. The above stone was placed at the cemetery in 1997.

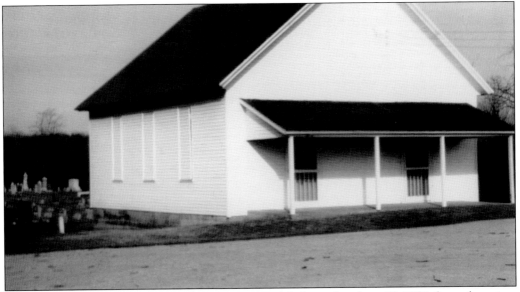

Before the Hinthorn-Union Chapel was erected and dedicated on June 19, 1904, funeral services were held in the Pleasant Grove schoolhouse. With automobiles prevalent, little use was made of the chapel except for funerals. From 1959 to 1964, lake residents and neighbors held summer services at the chapel. There have been recent weddings in the chapel, but the Agape Fellowship with Gary Ballard as pastor held the last services in the late 1970s. Of interest is a mural of the Last Supper on the wall of the chapel, painted by George Swan in 1914.

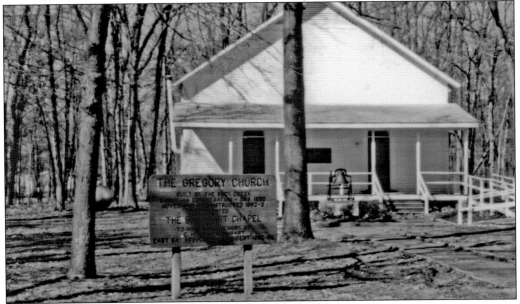

The Gregory Church was removed from the crossing of Gridley Road and the old Peoria Trail to Lake Bloomington's east side in early 1960. In 1964, the 1869 church known as both the Gregory Church and Buck Creek Christian Church was renamed Baumgart Chapel in honor of Herman Baumgart, East Bay Associates president from 1952 to 1962. Since the summer of 1964, the lake area's Congregation of Good Neighbors, who had previously met in Hinthorn-Union Chapel, have been meeting at Baumgart Chapel.

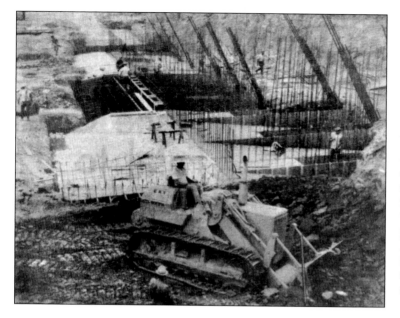

Beginning in 1968, the City of Bloomington began constructing Evergreen Lake 5 miles north of Hudson; the lake's source was Six Mile Creek. The approximate cost of building the lake was $5 million. Before starting on a pumping station to push water from Evergreen Lake to the water treatment plant at Lake Bloomington, new roads were constructed around the perimeter of Evergreen Lake.

Pictured are sailboats at Evergreen Lake. Comlara (acronym for County of McLean Lake and Recreation Area) is a park surrounding the Evergreen Lake area. Through a 60-year lease agreement with the City of Bloomington, McLean County was charged with developing the recreational area. An enclosed beach with a two-level bathhouse opened in 1975. There are trails for hiking as well as camping and picnic areas. Boating, fishing, and triathlons attract over 250,000 visitors each year. (Courtesy of W. Howard Smith.)

Ten

ESTABLISHING THE LIBRARY

The book *Pathfinder*, with a copyright of 1900, is stamped "Hudson Reading Room" on the title page. With Aura Johnston's name in the book, it is a clue that the Hudson Reading Room may have been in the post office or a business. Lora Johnston was the postmaster at this time, and she chaired the Hudson Woman's Club Hudson Reading Room. It would be another 80 years before Hudson residents had a library.

THE PATHFINDER

OR

THE INLAND SEA.

By JAMES FENIMORE COOPER.

Author of "The Last of the Mohicans," "The Deerslayer," "The Pioneers," "The Prairie," Etc.

" Here the heart
May give a useful lesson to the head,
And Learning wiser grow without his books."
—*Cowper.*

Hudson Reading Room

NEW YORK:
A. L. BURT, PUBLISHER.

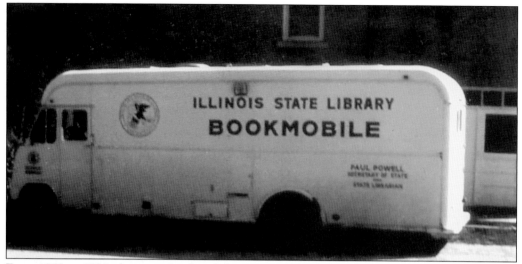

From 1968 to 1976, there was bookmobile service to Hudson. The bookmobile was loaned by the Illinois State Library to the Corn Belt Library System for one year to communities without public libraries. After a year, communities had the option to continue the bookmobile for a fee or establish a library of their own. To continue service, HJWC voted to pay half the fee, and the village and Hudson Township paid the rest. The 1976 Hudson Bicentennial Commission voted to proceed to establish a library. A referendum for a library was defeated in March 1976.

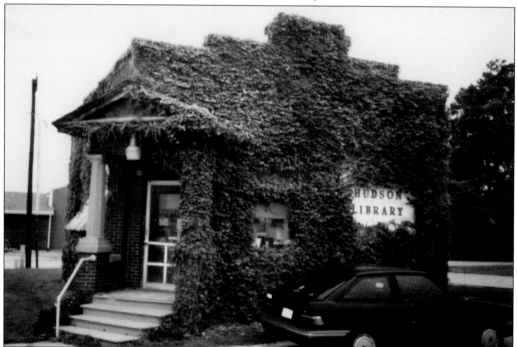

Constructed in 1901, the old bank building on Shiner Street was photographed in 1980 just after the Hudson volunteer library was established. It was leased by the library from Alexander Lumber Company for $1 per year. Vines had to be cut in order to open the door. The bank had folded during the Depression in April 1937. Afterward, it was an office for Dr. George McGee, a residence, and then vacant.

After voting at a meeting in 1979 to establish a volunteer Hudson Public Library, HJWC held a book drive in 1979 to supply the library with a collection. Book drop boxes were placed in businesses and Eastland Shopping Mall, and a contest was held at the elementary school. Over 5,000 books were collected in two weeks. HJWC members sorted texts into categories for cataloging. Cynthia Bouk (left) and Catherine Haab carry books into the volunteer library for sorting.

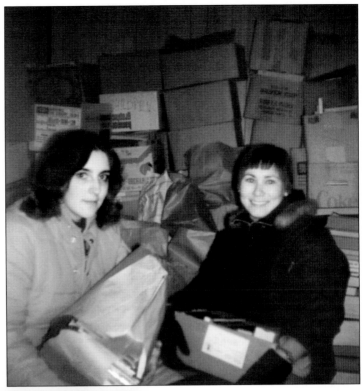

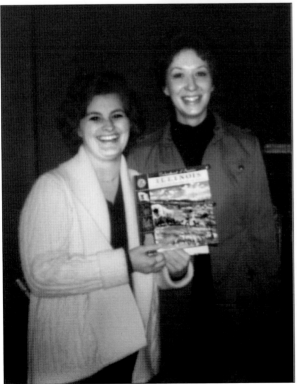

With professional advice, HJWC members and volunteers were taught to process the donated books. With documentation establishing the volunteer library, HJWC won the state General Federation of Women's Clubs Community Improvement Award in 1982. HJWC 1982 past president Pamela Bloom (left) and Nancy Becker hold the first book processed for the volunteer Hudson Public Library.

119

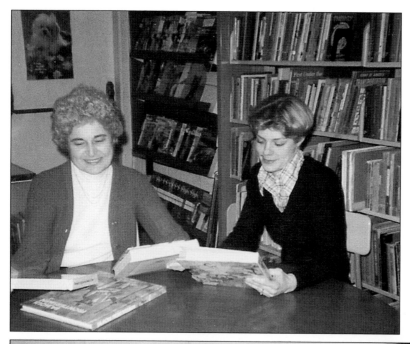

Jean Hanson (left), Normal Unit Five school librarian at Hudson Elementary, helped with cataloging and promoted a book fair for new books for the library. Kristi Menestrina, an HJWC past president, looks at new donated books in the library. The volunteer Hudson Public Library officially opened in April 1980.

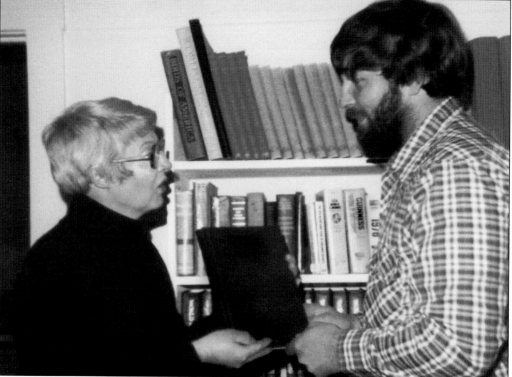

Phyllis Gumbrell (left), first librarian for the volunteer library, receives a new set of encyclopedias from Hudson Lions Club member Richard Leverenz. After a petition supporting the library was signed by over 300 Hudson residents, Hudson Township donated $500 to the volunteer library. The HJWC and the Village of Hudson each supported the library with $450 donations.

The Open House held December 23rd at the Hudson Library was a huge success. Special guest was Mr. Richard Peck, New York City novelist and journalist. Mr. Peck, a very personable and pleasant man, autographed his books for the public. Everyone enjoyed talking to him and taking pictures. Head librarian, Phyllis Gumbrell, and members of the HJWC hosted the event, and it was a special event to be remembered.

Richard Peck

Before author Richard Peck, a native of Decatur, Illinois, made his appearance at the Hudson Public Library's open house on December 23, 1980, he had dinner with his cousin, Ruth Aber, in Hudson. He is the author of *Father Image, Secrets of the Shopping Mall* and other young-adult books. After Peck's return to New York, the library received the letter at right from him.

```
                                    10 Mitchell Place
                                    New York, N.Y. 10017
                                    December 29, 1980

Dear Mrs. Gumbrell,

    This is only to say thank you for all your fine
hospitality in Hudson. That may have been the smallest
library of my experience, but it was also the friendliest,
and I have you all to thank for that, as well as my
favorite cousin, Ruth. I wish we all lived nearer
one another.

    And I hope you'll convey my thanks to the organization
of Hudson women for their hospitality too. How different
this country would be if every town cared as much about
books and a library as Hudson does.

    I hope to see you on my next visit.

                                    Sincerely,

                                    Richard Peck
```

PROPOSED BUDGET - MAY 31, 1982 to MAY 31, 1983:

EXPENSES - ANTICIPATED

Librarian...	$ 720.00
Insurance...	230.00
Heating...	500.00
Utilities (Water & Lights)............................	225.00
Lease...	5.00
Supplies (shelving, book processing, stamps)..........	160.00
Bank service..	5.00
New books...	200.00

Total anticipated expense...................... $2045.00

NOTE: LIONS CLUB DONATED 1981 set of WORLD BOOK ENCYCLOPEDIAS

ANTICIPATED INCOME

Village...	450.00
Hudson Juniors (includes books).......................	450.00
Township..	800.00
New cards and renewals................................	175.00
Fines...	35.00
Fund raisers (book sales, other donations)............	135.00

Total anticipated income..................... $2045.00

HJWC handed over the operation of the volunteer Hudson Public Library in September 1980. Board members represented organizations and the public. Volunteer board members were Judith Lampert, HJWC; Braxton Slappey, village; Ruth Cope, township; Charles Payton, Lions Club; and Jean Hanson, member at large. A sample of the library's early budget is above. Financial support from the village, township, and HJWC continued until the library became tax supported.

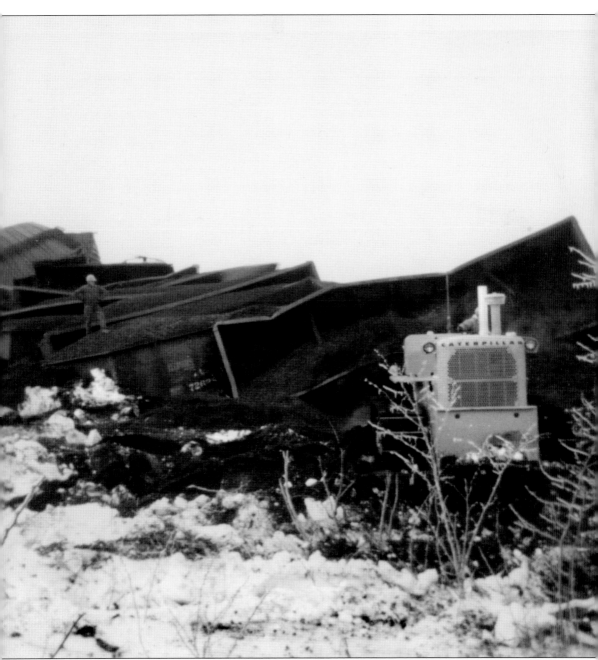

In the mid-1980s, residents urged the board to establish a tax-supported library. Working with the Corn Belt Library System, the library received a Project Plus grant to run a demonstration program showing the benefits of tax support. After the program, residents voted for a tax-supported library in 1990. This 1967 train wreck became an obstacle before building began. Parts of the train had been buried on the site where the new library building was under construction west of the school. After successful compaction tests, construction of the library began.

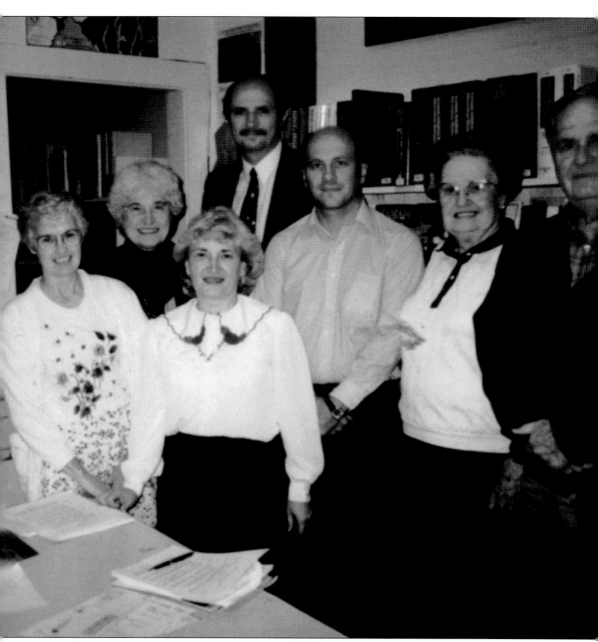

After the positive vote to establish a library, the first board of trustees was appointed by the county. Standing in the volunteer library are, from left to right, (first row) Dolores Bauman (first tax-supported librarian) and Judith Lampert; (second row) Jean Hanson; (third row) Robert Mentzer, Gregory Alt, Ruth Cope, and Fred Mills. This board worked with architect Russell Francois in the planning and construction of the new library. The official name of the library became the Hudson Area Public Library District (HAPLD).

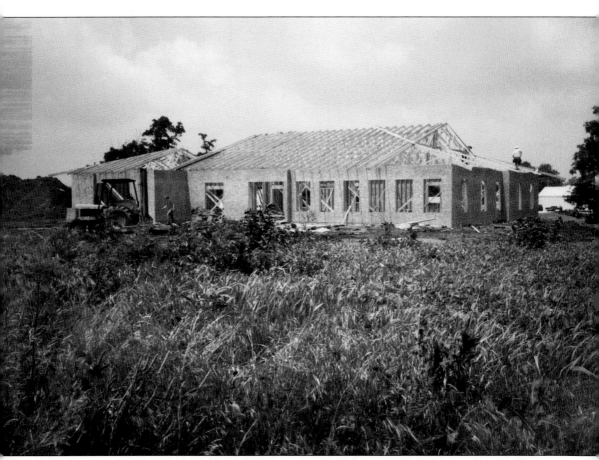

Pictured is the frame of the new library building. The land was bought from the village for $1. It was previously the site of the railroad right-of-way and tracks. With help from the State of Illinois and Hudson's Illini Bank, a new library building was being constructed. The library received a grant for 40 percent of the cost of building the library from the State of Illinois. The Illini Bank gave assistance by not requiring any payment on the mortgage until the new building was completed. Construction of the 5,000-square-foot building began in the spring of 1995.

Library books and equipment were moved to the new library beginning December 2, 1995. Hudson Elementary children helped move texts from the volunteer library to the new library. Noah Bachman is pictured moving a cart of books.

When the new library officially opened, the first patron to check out a book was Jennifer Beemer. An open-house celebration for HAPLD was held April 21, 1996. Sen. John Maitland was the guest speaker.

A Hudson History Room was included in the plans for the new library. Dr. Clark Heath contacted library personnel about the possibility of donating medical instruments that had belonged to his ▨▨▨-great-grandfather, Dr. Silas Hubbard. With a commitment from the library to permanently display the mid-1850s medical instruments belonging to Hudson's first doctor in an archival display case, Heath donated the instruments in 2007. Looking at the 1850s medical instruments are, from left to right, Janet Heath, Dr. Heath, and Judith Lampert, History Room volunteer.

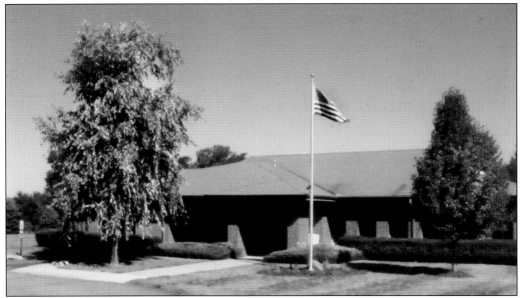

This photograph is HAPLD's library on Pearl Street as it appears in 2010. Land west of the library was purchased from the village in early 2000. Full-time employees are Kari Garman, library director, and Rhonda Johnson, youth services manager. The board of trustees includes Eric Cash, Anne Colloton, Laura Haas, Dee Hinrichsen, Judith Lampert, Stacy Shane, and Margaret Wolfe.

www.arcadiapublishing.com

Discover books about the town where you grew up, the cities where your friends and families live, the town where your parents met, or even that retirement spot you've been dreaming about. Our Web site provides history lovers with exclusive deals, advanced notification about new titles, e-mail alerts of author events, and much more.

MADE IN THE USA

Arcadia Publishing, the leading local history publisher in the United States, is committed to making history accessible and meaningful through publishing books that celebrate and preserve the heritage of America's people and places. Consistent with our mission to preserve history on a local level, this book was printed in South Carolina on American-made paper and manufactured entirely in the United States.

This book carries the accredited Forest Stewardship Council (FSC) label and is printed on 100 percent FSC-certified paper. Products carrying the FSC label are independently certified to assure consumers that they come from forests that are managed to meet the social, economic, and ecological needs of present and future generations.

FSC
Mixed Sources
Product group from well-managed
forests and other controlled sources

Cert no. SW-COC-001530
www.fsc.org
© 1996 Forest Stewardship Council

Find Your Place in History.